IMAGES
*of America*

# PLYMOUTH

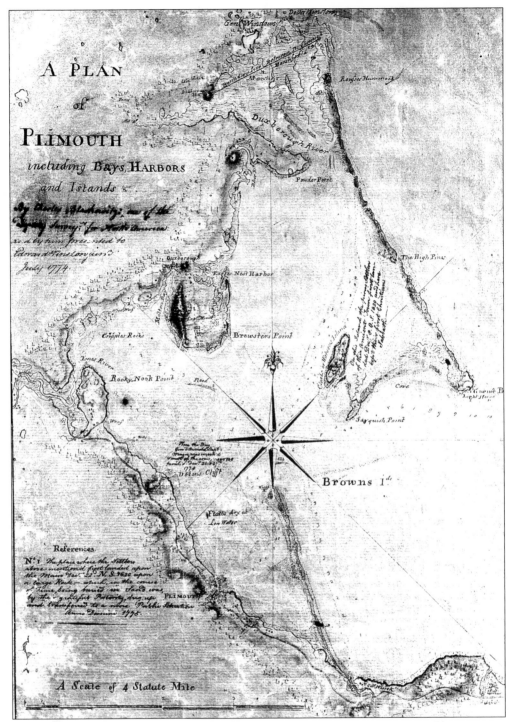

A 1774 SURVEY OF PLYMOUTH HARBOR BY MILITARY SURVEYOR CHARLES BLASKOWITZ.
This was Edward Winslow Jr.'s copy, with his notes mentioning the forefathers' landing on
Clark's Island, Plymouth Rock, and the wreck of the brig *General Arnold* in 1778. This is the
earliest recorded reference to the Pilgrims landing on Plymouth Rock.

IMAGES
*of America*

# PLYMOUTH

James W. Baker

ARCADIA

First printed in 2002.

Published by Arcadia Publishing,
an imprint of Tempus Publishing, Inc.
2A Cumberland Street
Charleston, SC 29401

Printed in Great Britain.

Library of Congress Catalog Card Number: 2001099422

For all general information contact Arcadia Publishing at:
Telephone 843-853-2070
Fax 843-853-0044
E-Mail sales@arcadiapublishing.com

For customer service and orders:
Toll-Free 1-888-313-2665

Visit us on the internet at http://www.arcadiapublishing.com

*This book is fondly dedicated to Maggie Mills, Plymouth's*
*indefatigable topographer, and to my wife, Peggy M. Baker, director*
*of Pilgrim Hall Museum, for all her patience and support in this project.*

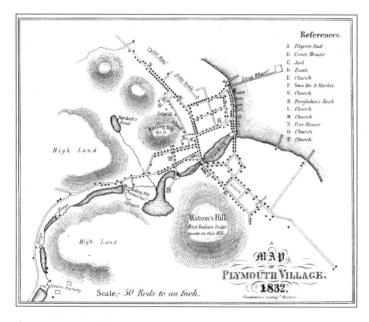

**AN 1832 MAP OF PLYMOUTH VILLAGE.** This map is from James Thacher's *History of the Town of Plymouth from its First Settlement in 1620 to the Present Time*, published in Boston in 1835. Note the long Robbins' Company ropewalk extending from Water Street to where the Run of the Mill Restaurant is today. The Plymouth population was only about 5,000 in 1832, and most lived in the Plymouth Village center.

# CONTENTS

# ACKNOWLEDGMENTS

I would like to thank the Pilgrim Society, which provided the bulk of the images used in this book. I also extend profound thanks to my brother Tony Baker, who made all of the copy prints. Thanks also go to the Old Colony Club of Plymouth and president Roger Randall for pictures lent from its inestimable collection. Thanks, too, to Plimoth Plantation and my longtime friend and colleague, research librarian Carolyn Freeman Travers; research assistant Hannah Rossoff; and Marie Pelletier and Die Hoxie in the graphic arts department. Lastly, I owe a special debt of gratitude to the Plymouth Public Library and my fellow staff members, including director Dinah Smith-O'Brien and reference masters Lee Regan and Bev Ness, whose encouragement meant so much.

# INTRODUCTION

Plymouth is best known as "the Pilgrim Town," where the famous events of 1620 marked the beginning of New England and, by extension, all of British North America. The Pilgrims of Plymouth have long been considered, in the words of Samuel Eliot Morison, "the spiritual ancestors of all Americans." This is, of course, patently unfair to Virginia, which was there first in 1607. However, it was Plymouth, not Jamestown, that captured the imagination of the world and is now universally regarded as America's birthplace.

Yet, the Pilgrims were only the first among the innumerable immigrants who arrived on these shores. Plymouth was never frozen in the image of its first settlers. When the English American colonies were primarily British in origin, Plymouth was a typical coastal community of the time—homogeneous in population and culture. Nevertheless, the town had ties to the outside world through fishing and shipping and its role as a port of entry. In addition, there had long been a small but vital number of Native American and African American families among the old Yankee clans.

Plymouth found a pioneering role in the new industrial economy that attracted a new pattern of European immigration. Emigrants from Ireland, Canada, and Germany, seeking work in the new mills along Plymouth's brooks and shores, transformed the town by the 1850s. At the end of the century, the town benefited again from the second wave of immigration, which brought families from Italy, Portugal, Finland, England, Russia, and even China. The Old Colony town's demographics, far from being limited to Pilgrim stock, reflected those of the nation at large.

The 20th century saw no abatement in this cycle of growth and change. By midcentury, the new highway system superceded the railroad and streetcars. It brought an explosion in population, introducing the ex-urban pattern of housing developments and commercial sprawl that became characteristic of the American communities everywhere. Shorn of its mills and with many of its early neighborhoods and woodlands lost through progress and urban renewal, Plymouth was transformed once again. Far from being an isolated tourist attraction with a pure Anglo-American past, Plymouth is uniquely representative of the entire American experience, from its Colonial roots to today's postindustrial society.

As with most New England towns, the earliest scenes are now beyond recall. We have no pictures of our Pilgrim beginnings or any image at all before the start of the 19th century, when English traveler John Lambert first depicted the town from the harbor entrance. It was the invention of photography that made it feasible to fully record the passing of the old and the advent of the new. Plymouth made good use of this medium to rescue the past from oblivion. We are beneficiaries of enterprising photographers, such as W.S. Robbins, J.C. Barnes, and E.P. McLaughlin, as well as many anonymous camera carriers. We are in debt, too, to the town's

premier publicist and souvenir purveyor, Alfred S. Burbank, whose enthusiasm for Plymouth was not limited to the Pilgrims but also included the contemporary town as well.

This book is a family album of "America's Home Town," a pictorial retrospective of the people and places from Plymouth's past two centuries of existence. These images are largely those that no longer exist—except in memory. They show how the town evolved from a rural fishing village to the post–World War II community in which many contemporary Plymoutheans grew up. The pictures date primarily from the 1890s to the 1950s and depict a Plymouth that was still an independent, self-contained community with a population of one third or less of what it is today.

The first chapter focuses on Plymouth's historic houses as they looked before they were "restored" or destroyed. These dwellings, presented in roughly chronological order, hearkened back to Pilgrim times and, like Plymouth Rock or Pilgrim Hall's artifacts, acted as tangible touchstones to an authentic Plymouth past.

The second chapter encompasses Plymouth's vanished industrial landscape when the town was dominated by its mills and factories during the 19th century. Manufacturers used the waterpower of Town Brook, Eel River, and even Hobs Hole Brook to produce ironware, tacks, rope, cotton, and woolen cloth. They ranged in size from Ichabod Morton's quaint gristmill to the massive Plymouth Cordage Company, which single-handedly created the North Plymouth community.

The third chapter presents the local stores and businesses that supported the people who worked and lived in Plymouth. It evokes the closeness of a community where everything from hardware to clothing could be found in downtown stores, and there were corner groceries and general stores in every neighborhood. Plymouth's links to the outside world before the automobile changed the face of the land are also represented, including the Old Colony Railroad, the steamboat lines, and the Plymouth and Kingston Street Railway.

The fourth chapter covers the Plymouth heritage industry, through which the town is best known to the outside world. Plymouth's monuments and shrines—from Pilgrim Hall (1824), the highly successful re-creation of our earliest settlement, and the nation's oldest historical museum to Plimoth Plantation—drew an ever increasing audience to the Pilgrims' landing place.

The fifth chapter is dedicated to civic Plymouth, its public buildings, and the community events that were enjoyed at a time before movies, television, or the Internet.

The final chapter depicts the town as it was known and lived in by the Plymoutheans themselves. Here we find the houses, families, and scenes that reflect a way of life now gone forever—not necessarily idyllic nor more leisurely, but a solid middle-class way of life that is the foundation for the town we know today. It is arranged in a spiraling order, from the oldest streets and their residents at the center of town to the more distant parts of the township. We hope these images of Plymouth's yesteryears will give our fellow townsfolk and all the many visitors who have come here as much pleasure to recall as has been ours in gathering them for publication.

# One

# PLYMOUTH'S
# EARLIEST SCENES AND
# HISTORIC HOUSES

_Plymouth, Massachusetts, where the first Colonists landed in New England._

**A VIEW OF THE ENTRANCE TO PLYMOUTH HARBOR, C. 1800.** This rather fanciful illustration depicts the view of Plymouth from the Gurnet. Note the beacon on the bluff to the right, the tree on Saquish, the woods on Plymouth Beach, and one of the two breaks through the beach that occurred in 1778.

THE PLYMOUTH TOWN SQUARE, C. 1812. From left to right are the *c.* 1698 Shurtleff House, later moved farther south on Market Street; the 1749 Plymouth Court House; and the 1744 First Parish Church. The elm trees were imported from Portsmouth, New Hampshire, and planted by Capt. Thomas Davis in 1784. Note the figures below the courthouse, where a father seats his son on Plymouth Rock, located there from 1774 to 1834.

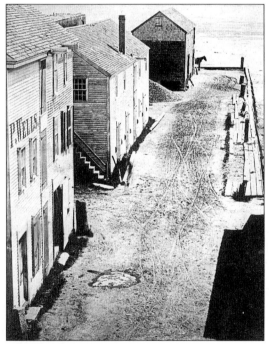

THE LOWER HALF OF PLYMOUTH ROCK, C. 1855. This early view shows Plymouth Rock embedded in Hedge's Wharf in front of Phinehas Wells's warehouse. Work on the canopy designed by Hammatt Billings began in 1859.

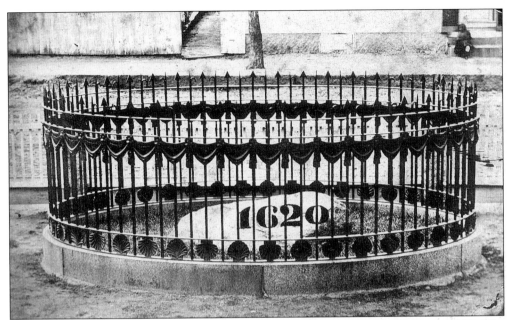

**PLYMOUTH ROCK IN ITS CAST-IRON ENCLOSURE IN FRONT OF PILGRIM HALL, C. 1870.** The rock was moved to the hall grounds from the Plymouth Town Square in 1834, before being reunited with its lower half beneath the Billings's canopy in 1880. Note the painted date on the rock.

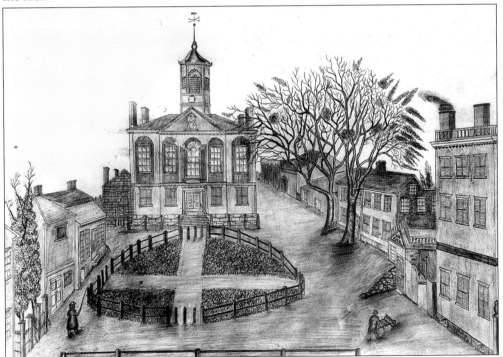

**COURT SQUARE IN AN ANONYMOUS DRAWING, C. 1845.** The Hedge house (now Compass Bank) is on the far right. Mrs. Nicholson's boardinghouse is behind the two trees, where the bank parking lot is today.

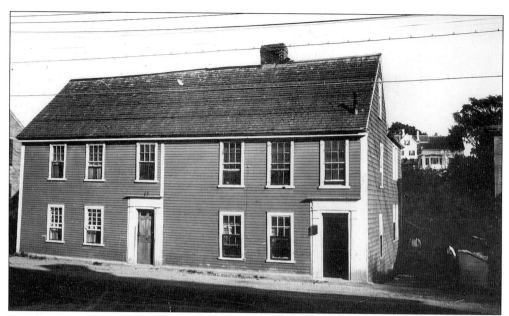

**THE SPARROW HOUSE, AT 42 SUMMER STREET, C. 1920.** The Sparrow House, built sometime after 1640 by Richard Sparrow, was renovated by Strickland and Strickland in 1934 and managed as a historic site by Katherine Alden, who also ran the Plymouth Pottery from the house and adjoining 44 Summer Street.

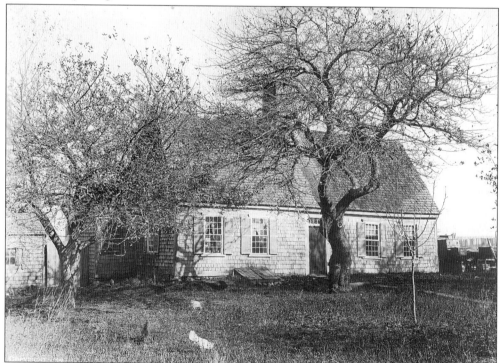

**THE DOTEN HOUSE, ON SANDWICH STREET, IN A VIEW LOOKING EAST, C. 1900.** Built c. 1660 by William Harlow, the house was bought by Nathaniel Doten in 1773. It was torn down c. 1900. The Doten house was across from where the medical center at 137–139 Sandwich Street is today.

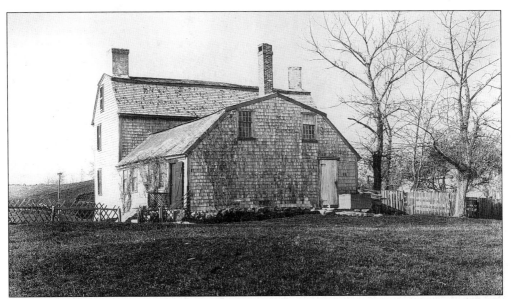

THE CROWE HOUSE, AT 393½ COURT STREET, IN A VIEW LOOKING WEST, C. 1890. Built in 1664, the old house formed the ell of the 18th-century Jackson House, both of which were allowed to fall into ruin after a fire and were removed in 1993.

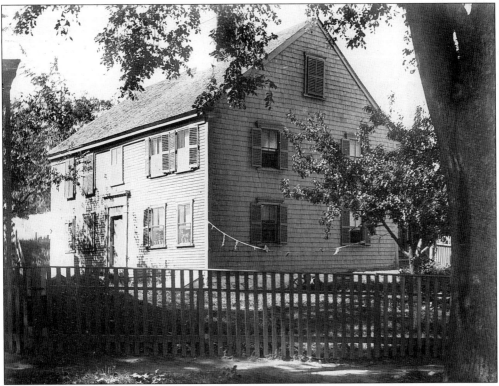

THE HOWLAND HOUSE, ON SANDWICH STREET, C. 1900. Built by Jacob Mitchell in 1667 and subsequently owned by Jabez Howland, the house was bought by the Howland Descendants in 1912 and restored by Strickland and Strickland in 1942.

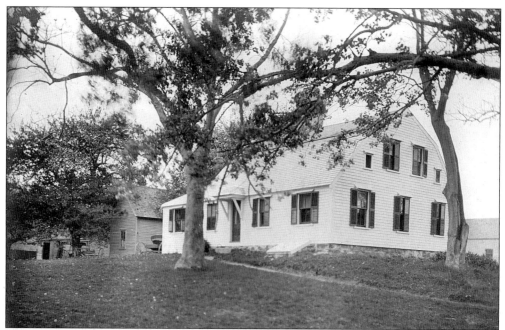

THE HARLOW HOUSE, AT 117 SANDWICH STREET, C. 1898. The Harlow House was built by William Harlow in 1677 with timbers from the last Pilgrim fort. The house was purchased by the Plymouth Antiquarian Society in 1920 and restored by Joseph Chandler.

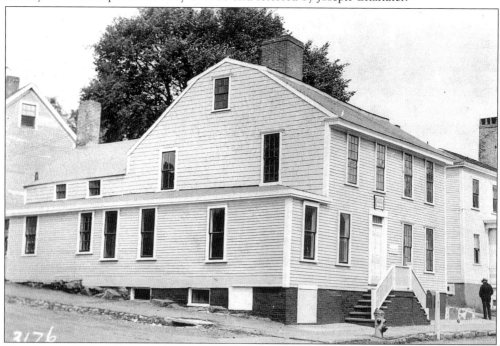

THE LEACH HOUSE, AT 47 SUMMER STREET ON THE NORTHEAST CORNER OF SPRING STREET, C. 1890. Built in 1679 by George Barrows, this house was demolished during the Plymouth Redevelopment Authority project c. 1965. The site is now the southwest corner of the John Carver Inn parking lot.

*LEFT:* EPHRAIM COLE'S BLACKSMITH SHOP IN A VIEW LOOKING SOUTHWEST. *RIGHT:* THE OLD POWDER HOUSE, C. 1880. The blacksmith shop, located behind Weston's Express Office on the corner of Leyden and Main Streets, burned down in 1913. The powderhouse, built in 1777 to store the town's supply of gunpowder, was torn down in 1880. A replica was erected in 1920 for the tercentenary.

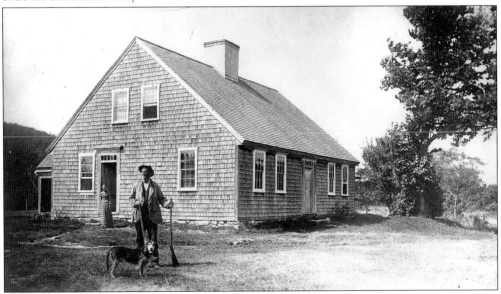

CORNISH'S TAVERN, ON OLD SANDWICH ROAD, C. 1900. Horatio Wright, a famous guide for sportsmen who came to Plymouth for hunting and fishing, stands near the 18th-century tavern he acquired in 1879. The property later became part of Robert Symington's 3,000-acre estate and game preserve and is now part of the Pine Hills development.

15

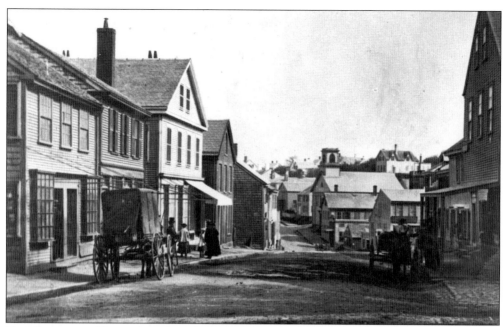

**THE SHURTLEFF HOUSE (LEFT), ON MARKET STREET, IN A VIEW LOOKING SOUTH, C. 1890.** Built in 1698 by William Shurtleff, the old house was originally on the corner of Market and Leyden Streets but was moved back and added to in 1847. The Robinson Methodist Church (1830), on the corner of Pleasant and Robinson Streets, was occupied by the Bradford and Kyle Company between 1894 and 1905 and later by carpenter Carroll Howland.

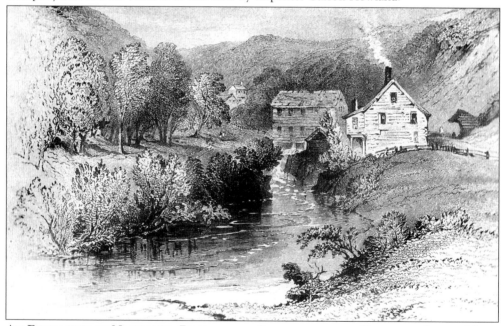

**AN ENGRAVING OF NATHANIEL RUSSELL AND COMPANY, AT THE PLYMOUTH LOWER MILLS ON TOWN BROOK.** This engraving, taken from W.H. Bartlett's *The Pilgrim Fathers* (1853), depicts the view west from about the beginning of Billington Street. There was a forge here operated by William Crombie before 1800.

# Two

# PLYMOUTH MILLS
# AND FACTORIES

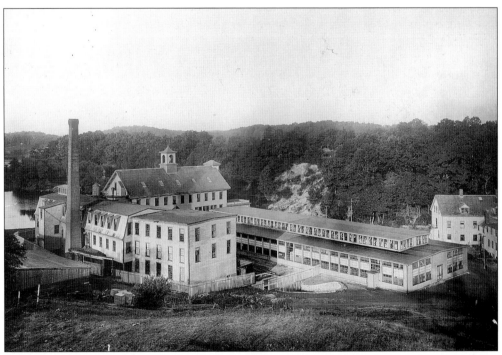

THE STANDISH WORSTED COMPANY, ON BILLINGTON STREET, IN A VIEW LOOKING NORTHWEST, C. 1900. The low mill building on the right is all that survives today. Earlier businesses on this site included a leather mill in 1771, a snuff mill in 1788, and a cotton cloth factory in 1812.

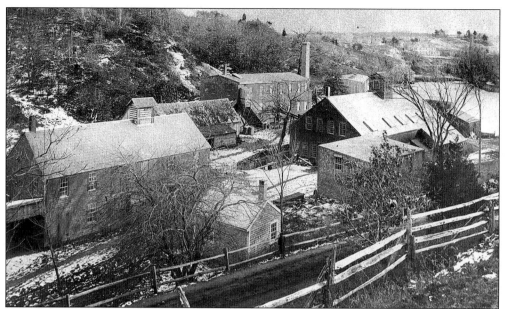

THE PLYMOUTH UPPER MILLS IN A VIEW LOOKING SOUTHWEST ACROSS BILLINGTON STREET, C. 1880. A forge built here by Solomon Inglee before 1790 manufactured anchors, plough shares, and sleigh shoes. Bought by Nathaniel Russell and Company in 1806 for the production of nails, it became part of Plymouth Mills in 1854, closed in 1926, and was removed in the early 1940s.

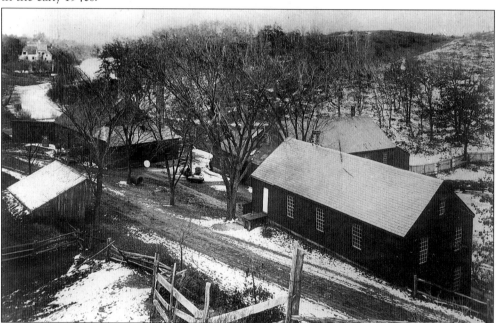

THE PLYMOUTH MILLS, THE LOWER WORKS, IN A VIEW LOOKING SOUTHEAST ACROSS BILLINGTON STREET, C. 1880. An anchor forge here was built by Heman Holmes in 1800, and Oliver Edes began the manufacture of rivets in 1844. The mill buildings burned down in 1966. The covered wooden footbridge built by the Plymouth Boy Scouts, where the water main from Billington Sea crosses Town Brook, is today just beyond the last building to the left.

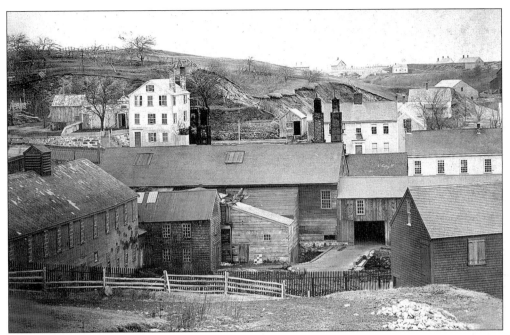

THE ROBINSON IRON WORKS, ON NEWFIELD STREET, IN A VIEW LOOKING NORTH FROM CANNON HILL TO SUMMER AND EDES STREETS, C. 1880. Newfield Nursing Home is now on Cannon Hill. The rolling and slitting mill begun by Nathaniel Brimmer in 1792, became Robinson Iron in 1866. Now, it is the Samuel W. Holmes playground and skateboard park. Note the lack of trees allowing a view of Cow's Hill (left) and Gallows Hill and Davis Street (right).

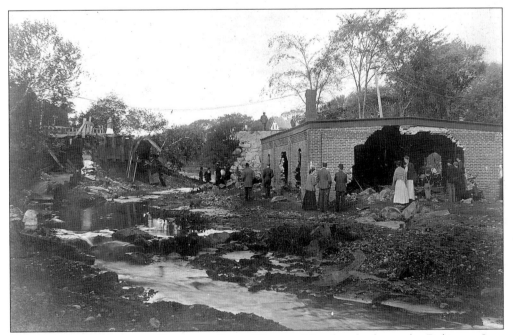

THE DAM BREAK AT THE ROBINSON IRON WORKS. The dam broke at the Robinson Iron Works, located on Summer and Newfield Streets, on September 24, 1906.

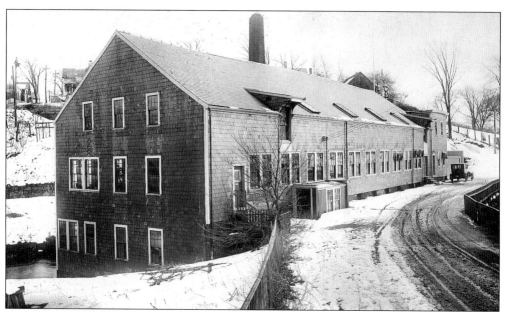

THE BRADFORD AND KYLE COMPANY, ON SPRING LANE, C. 1925. This mill was originally a tack manufactory begun by Samuel Loring in 1863. The Bradford and Kyle Insulated Wire Company operated here from 1905 to 1966. The building was demolished in 1968, and the re-created Jenney gristmill now occupies the site.

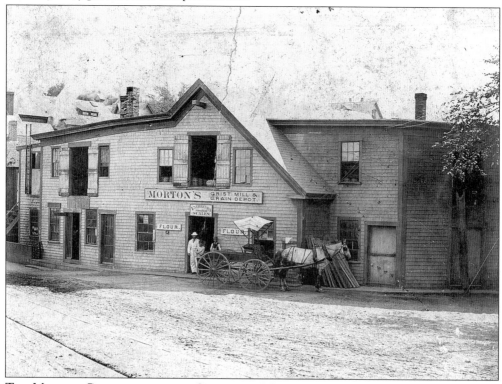

THE MORTON GRISTMILL, ON THE CORNER OF MARKET AND MILL STREETS, C. 1885. The mill was on the north bank of Town Brook at the Market Street Bridge.

ICHABOD MORTON IN HIS GRISTMILL, AT 47 MARKET STREET, C. 1900. Morton's was Plymouth's last gristmill. It had been built by the Bramhall family in the mid-18th century and continued in operation into the 1920s.

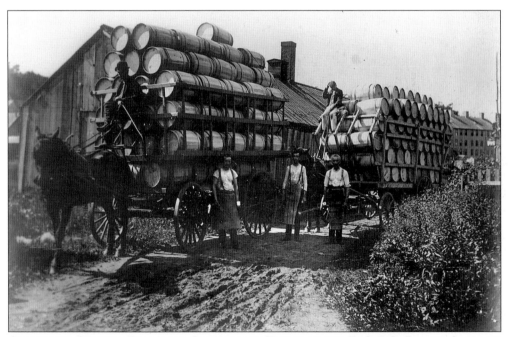

CRANBERRY BARRELS READY FOR SHIPMENT IN FRONT OF THE E. & J.C. BARNES SAW AND PLANNING MILL, C. 1890. The Barnes factory was located in part of the old Robbins' ropewalk on the Town Pond, where the entrance to Brewster Gardens is now.

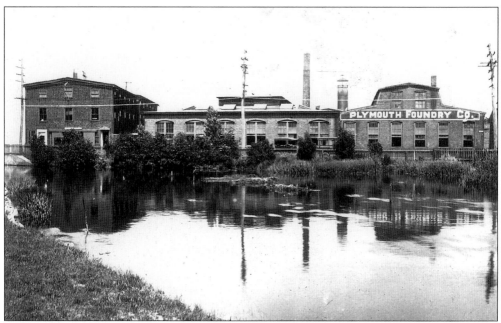

THE PLYMOUTH FOUNDRY, ON WATER STREET, C. 1900. The Plymouth Foundry was incorporated in 1866 from a foundry established by W.R. Drew in the 1840s. It made stoves and "hollow ware" (iron pots and kettles) until electric stoves and lighter cookware became popular. The business closed in 1935.

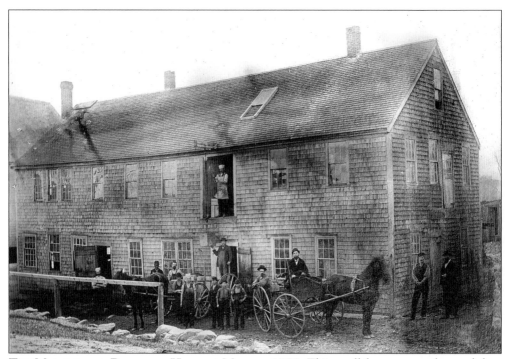

THE MANTER AND BLACKMER HAMMER MILL, C. 1890. This small factory manufactured shoe shanks, hammers, and other ironware until c. 1895.

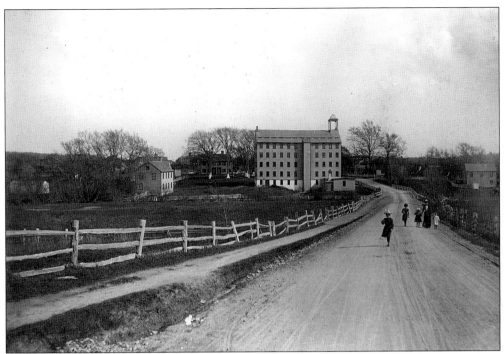

THE HAYDEN MILL, ON SANDWICH ROAD, IN A VIEW LOOKING SOUTH, C. 1890. This large yellow building was begun in 1812 and enlarged over the next 80 years. It manufactured cotton cloth, especially duck for sails, but burned down in 1913.

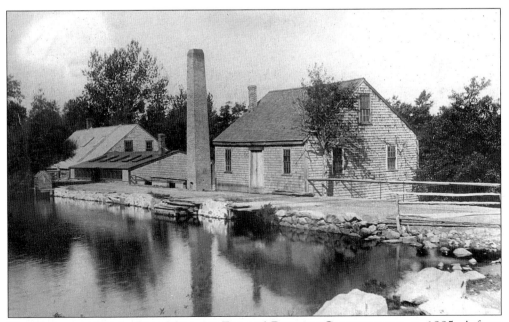

THE EDES AND WOOD ZINC MILL, ON FORGES' POND IN CHILTONVILLE, C. 1885. A forge built in 1830 was bought by Oliver Edes and Nathaniel Wood, who moved their zinc operations here from Town Brook in 1850. The company moved to Water Street in 1892.

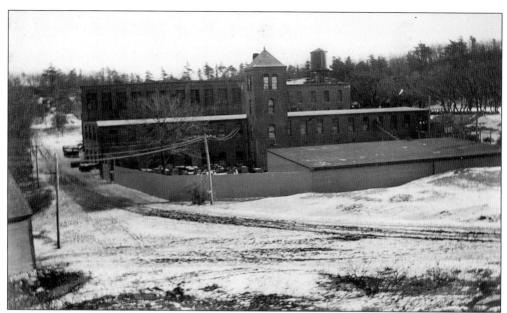

**THE BOSTON WOVEN HOSE AND RUBBER COMPANY, IN RUSSELL MILLS IN CHILTONVILLE, c. 1930.** This view was taken from the hill behind the "Long House" mill residence. The site had been developed by Nathaniel Russell and Company in 1827 as an iron mill. It became a cotton mill in 1855 and then a hose and rubber factory in 1903.

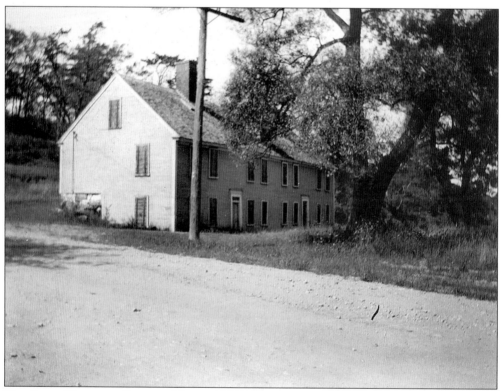

**THE LONG HOUSE IN RUSSELL MILLS, 1933.** This view was taken from the mill side.

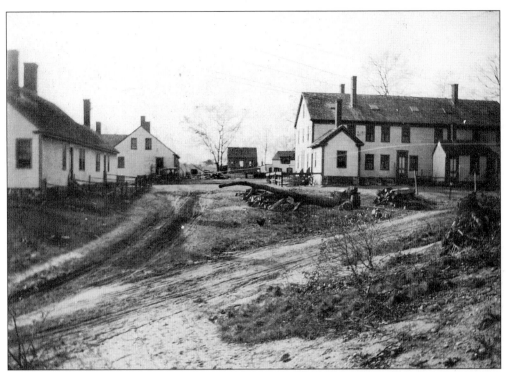

**RUSSELL MILLS WORKERS' HOUSING.** This view of the Russell Mills workers' housing, located in Chiltonville, was taken in 1920.

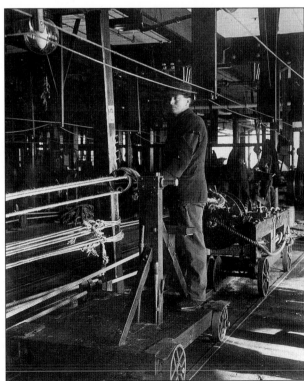

**LAYING SMALL ROPE AT THE PLYMOUTH CORDAGE COMPANY, c. 1900.** This image shows workers laying small rope at the Plymouth Cordage Company.

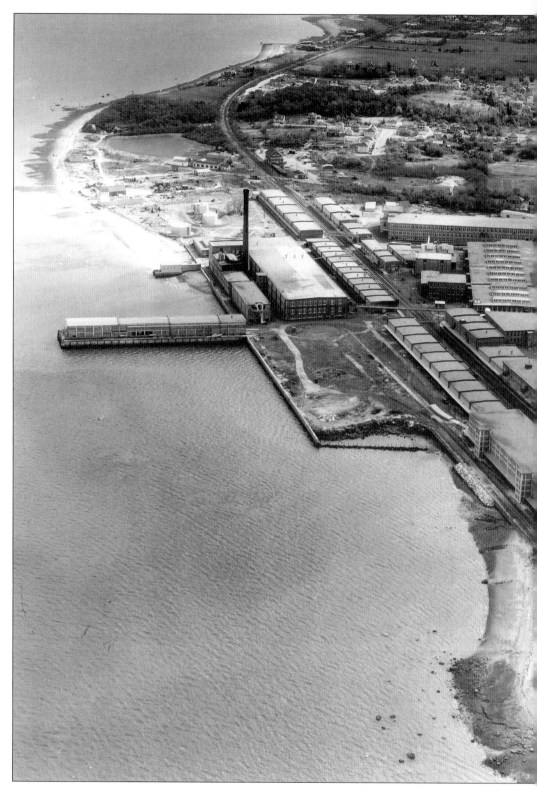

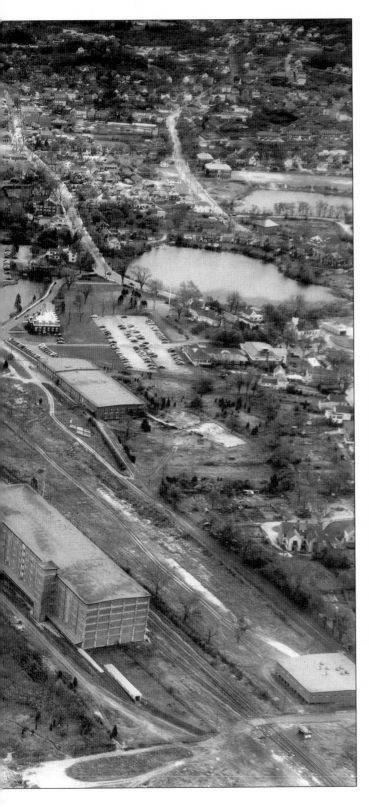

**THE PLYMOUTH CORDAGE
COMPANY, IN NORTH
PLYMOUTH, C. 1945.**
Founded in 1824 by Bourne
Spooner, the Plymouth
Cordage Company became
not only the town's most
significant industry but also
the largest rope manufactory
in the world. The company
grew throughout the 19th
century, switching its
emphasis to baling twine
when rope rigging declined
in shipping. Its greatest
growth occurred after the fire
of 1885, when not only was
the old mill replaced but
others were added as well.
No. 1 Mill was built in 1885,
No. 2 in 1899, and No. 3 in
1907. The Plymouth
Cordage Company flourished
until after World War I, as
revenues dropped from $29
million in 1919 to $7 million
by 1939. The company was
sold to Columbia Rope in
1965 and went out of
business in 1971.

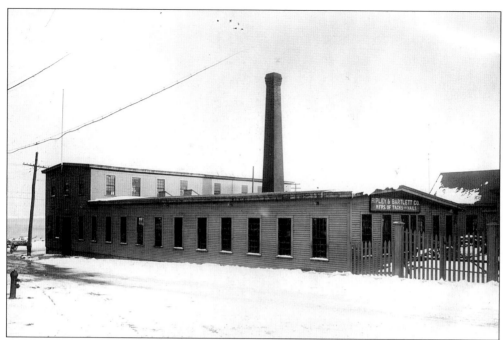

THE RIPLEY AND BARTLETT TACK FACTORY, ON WATER STREET, IN A VIEW LOOKING SOUTHEAST FROM PARK AVENUE, C. 1920. Ripley and Bartlett was still in operation in the 1950s. The site is now occupied by Al's Pizza.

THE PLYMOUTH WOOLEN COMPANY IN A VIEW LOOKING SOUTH ACROSS MURRAY STREET, C. 1890. Founded in 1863, the mill became Puritan Mills under the American Woolen Company in 1900. Business declined after World War I, and the mill closed in 1955. The Sheraton Plymouth and Village Landing occupy the site today.

WATER STREET IN A VIEW LOOKING NORTH FROM THE FOOT OF BREWSTER STREET, c. 1910. The mill, with company housing just beyond, was bought by George P. Mabbett & Sons in 1907 and enlarged. Mabbett's was bought by Bernard Goldfine in 1952 and closed c. 1964. The surviving building now houses Isaac's Restaurant and other businesses.

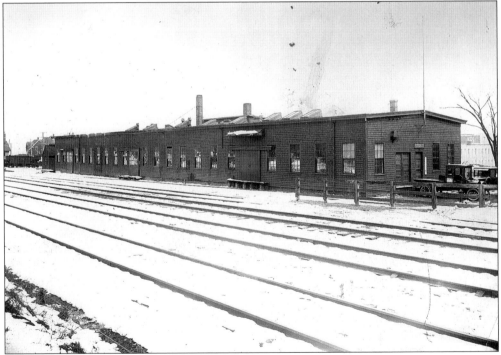

EDES MANUFACTURING, ON LOTHROP AND WATER STREETS, IN A VIEW LOOKING NORTHEAST, 1918. The Edes Zinc Factory had been at Forges' Pond on Shingle Brook (Eel River) from 1850 to 1892. The Water Street business later became Revere Cooper and Brass.

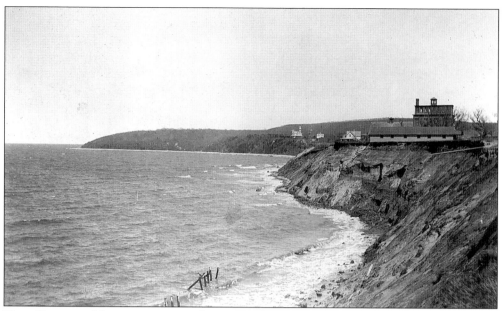

THE CHILTON MANUFACTURING COMPANY (SILICA WORKS), C. 1890. The Chilton Manufacturing Company was located on the bluff behind the Hotel Pilgrim, with Rocky Point and the Pine Hills beyond. The company processed beach sand for glassmaking before 1898. The long building on the right is the hotel's bowling alley.

# OLD COLONY RAILROAD.

## PASSENGER NOTICE
### FOR DECEMBER 22d.

For the accommodation of persons wishing to attend the Celebration of the Two Hundred and Twenty-Fifth Anniversary of the **LANDING OF THE PILGRIMS**, Trains will be run over the Old Colony Railroad, leaving Boston and Plymouth as follows:

BOSTON, at 5 o'clk, A. M.    PLYMOUTH, at 7 o'clk, A. M.
"        " 9        "              "        " 1      P. M.
"        " 9.30     "              "        " 6.30    "
"        " 3.30   P. M.            "        " 11
"        " 8.30     "              " on the 23d, at 4 A. M.

The 5, 9, and 9.30 A. M. Trains will leave the Passenger Station of the Boston and Worcester Railroad, corner of Lincoln and Beach streets. The other Trains will leave the Station at South Boston.

JOS. H. MOORE, Sup't.

BOSTON, Dec'r 15th, 1845.

B. N. DICKINSON & CO. Printers Boston

A HANDBILL FOR THE OLD COLONY RAILROAD ADVERTISING SPECIAL TRAINS FOR FOREFATHERS' DAY ON DECEMBER 22, 1845. The Old Colony Railroad had just begun service to Boston on November 8, 1845. The advertised special train brought about 500 dignitaries to celebrate the anniversary of the landing of the Pilgrims.

# Three

# PLYMOUTH COMMERCE AND TRANSPORTATION

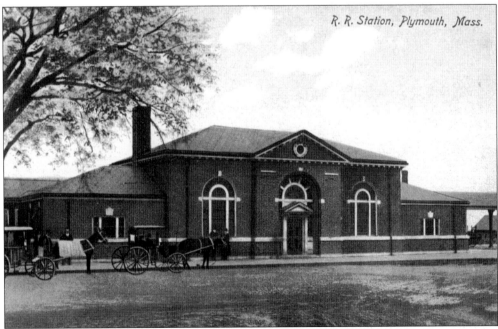

R. R. Station, Plymouth, Mass.

**THE NEW RAILWAY STATION ON PARK AVENUE, 1905.** This station replaced an earlier one built in the 1860s and was, in turn, adapted by the Great Atlantic and Pacific Tea Company (A & P) in 1961. It was replaced by the Plymouth Five Cents Savings Bank in 1978.

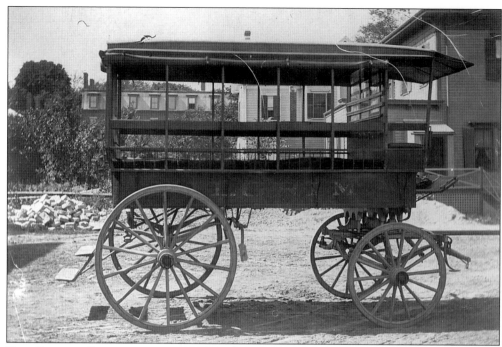

THE *PILGRIM* CARRIAGE, C. 1900. Popularly known as "the barge," this carriage brought workers to the Plymouth Cordage Company from Plymouth Center.

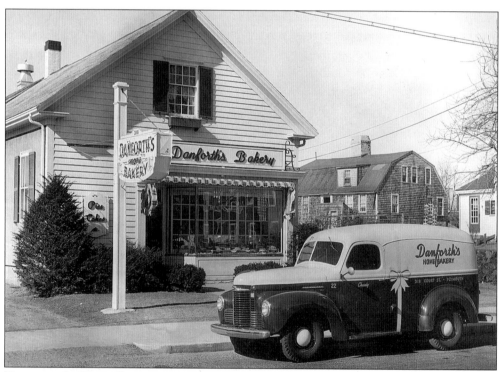

DANFORTH'S HOME BAKERY, AT 318 COURT STREET IN NORTH PLYMOUTH, C. 1950. Danforth's, with stores in North Plymouth and Plymouth Center, was a town tradition.

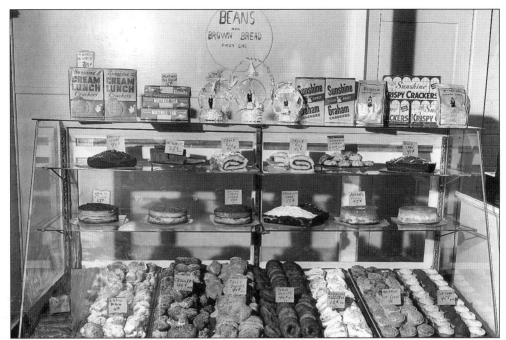

A DANFORTH'S HOME BAKERY DISPLAY CASE, THE 1940S. The hand-drawn sign for "Beans and Brown Bread Every Saturday" and the variety of crackers clearly identify the bakery's New England character.

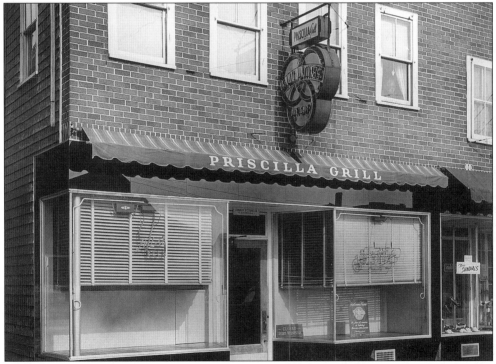

THE PRISCILLA GRILL, AT 301 COURT STREET, C. 1950. The Priscilla Grill was a longtime North Plymouth institution.

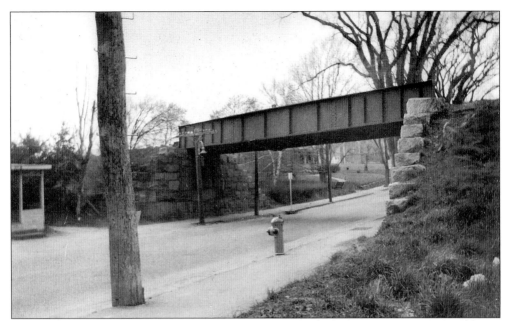

THE PLYMOUTH AND MIDDLEBOROUGH RAILROAD BRIDGE OVER COURT STREET IN A VIEW LOOKING SOUTHEAST, 1939. The railway line opened in 1893 and closed after World War I. The bridge crossed from what is now the south side of Standish Plaza to the Cold Spring Motel property.

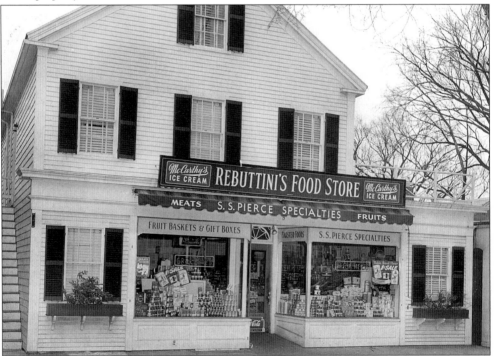

REBUTTINI'S MARKET, AT 53 COURT STREET, C. 1950. Pete Rebuttini's store was one of Plymouth's most popular markets. The name was commonly pronounced "Roobettini's" by its customers.

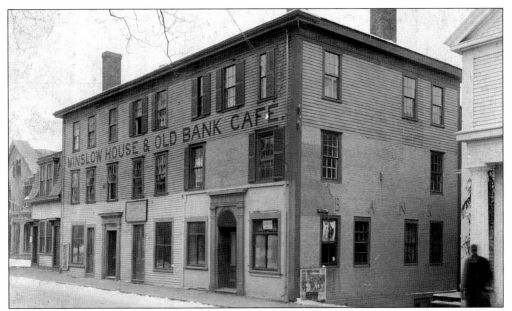

THE OLD BANK CAFÉ, AT 13–21 COURT STREET, C. 1880. The town's first bank, Plymouth Bank, was founded here in 1803. Plymouth National Bank later moved to the bank building at 44 Main Street and then to a new building at 58 Main Street, now part of the Puritan Clothing building. The old bank building was removed for the construction of the Russell Building in 1898. The Old Colony Club house is on the far left.

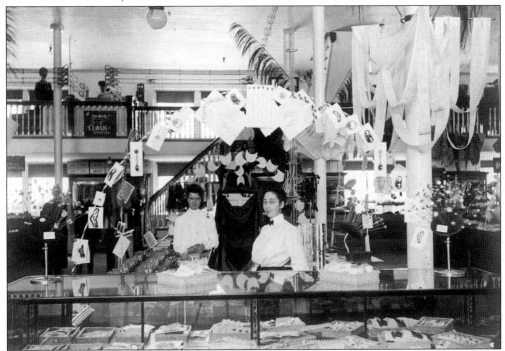

THE SALES COUNTER AT THE MOORE BROTHERS DEPARTMENT STORE, AT 4–8 COURT STREET, C. 1900. Moore Brothers was bought by Adams Company in 1918 and by E.A. Buttner in 1923. It is now the Plymouth Antique Trading Company.

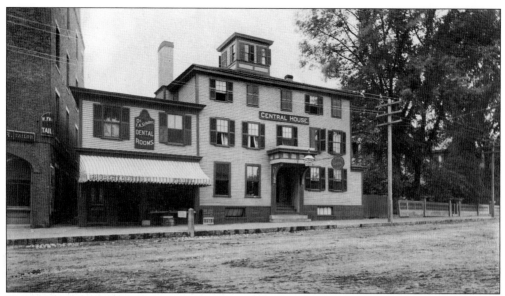

THE CENTRAL HOUSE HOTEL AND RESTAURANT, AT 56 MAIN STREET, C. 1900. The original building dated to 1698. As Ballard's Saloon in 1856, it did not serve liquor but rather the favored "fast food" of the time—oysters and ice cream. The Central House was torn down for the Puritan Clothing Company c. 1930. The building on the left, at 52 Main Street, became the popular Gambini's Restaurant. Davis Hall (the site of Woolworth's and Main Street Antiques), which burned in 1903, is on the far left.

THE BOSTON BOAT OFFICE AT LONG WHARF IN A VIEW LOOKING SOUTHEAST, C. 1885. Long Wharf was extended 1,000 feet in 1829 to accommodate the Boston steamboats by reaching to the end of the "Guzzle," or natural channel across the harbor. The extension had been removed before this picture was taken.

36

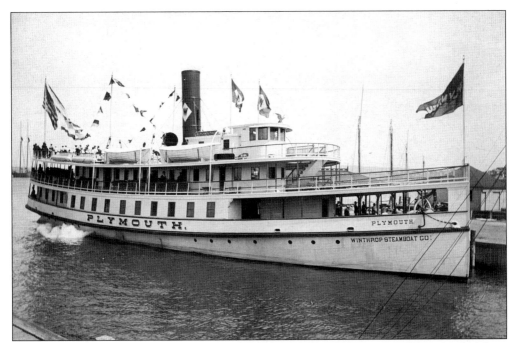

THE STEAMBOAT PLYMOUTH AT LONG WHARF, C. 1910. The first steamboat to travel from Boston to Plymouth was the *Eagle* in 1818, and others followed from time to time, but regular service only began in 1881.

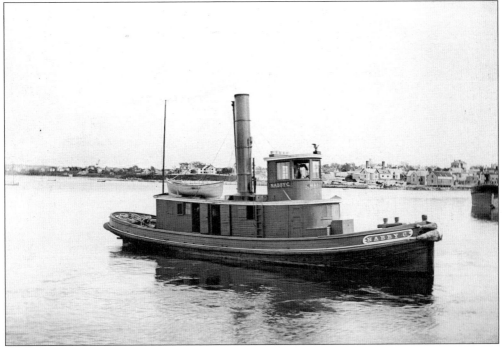

THE TUGBOAT NABBY C, 1900. Dexter Craig's well-known tug was Plymouth's harbor workhorse for many years. Craig was Plymouth's leading dealer in coal, hay, and grain, with a yard and wharf about where the state pier is today.

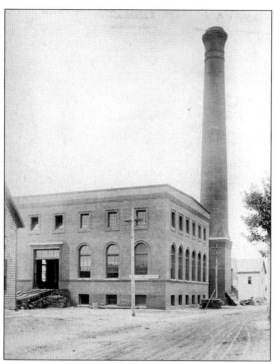

**THE BROCKTON AND PLYMOUTH STREET RAILWAY POWER STATION, ON WATER STREET, 1900.** The new power station was built following the consolidation of the Plymouth and Kingston line with the Brockton Street Railway Company in 1900. It was located about where the state pier approach is today.

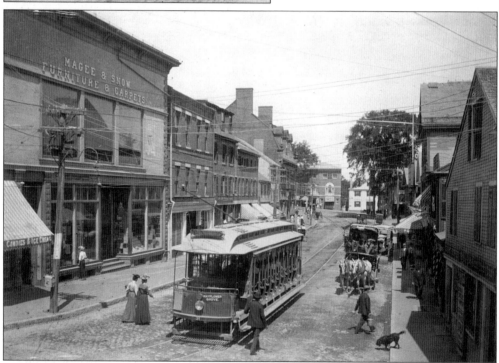

**MAIN STREET IN A VIEW LOOKING NORTH FROM LEYDEN STREET, C. 1900.** Note the Brockton and Plymouth Street Railway car (with a sign for Mayflower Grove, the popular amusement park in Bryantville) about to turn into the town square and cross the Market Street Bridge before continuing on to Fresh Pond in Manomet.

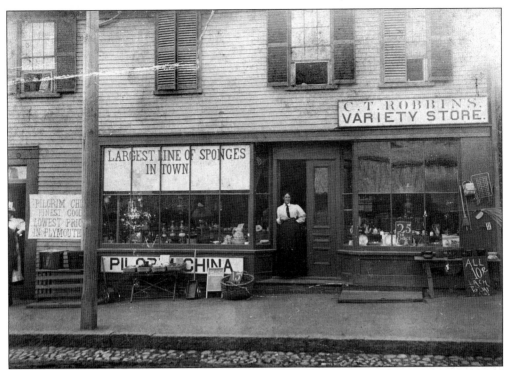

**CALEB T. ROBBINS' STORE, AT 38 MARKET STREET ON THE EAST SIDE.** This store was located near the site of the present-day Dunkin' Donuts parking lot.

**THE PLYMOUTH BAKING COMPANY, AT 20 MARKET STREET ON THE EAST SIDE.** This building was about where the rear of the downtown Dunkin' Donuts shop is today.

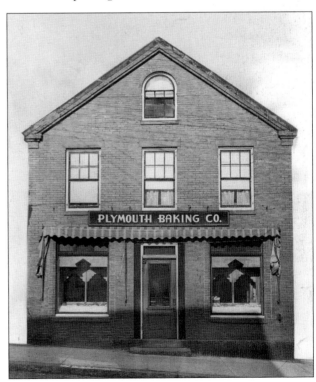

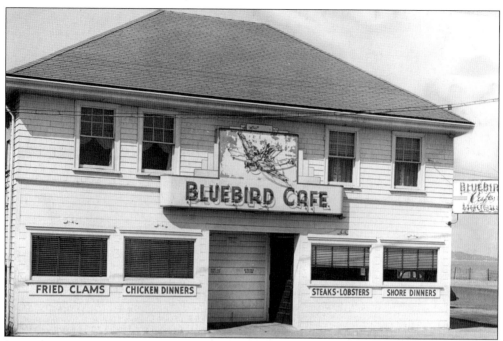

**THE BLUEBIRD CAFÉ, C. 1947.** Opened by Albert White in the mid-1920s, the restaurant remained in the White family until its sale to the Ocean Spray Corporation in 1998. It was renamed the 1620 Restaurant in 1968.

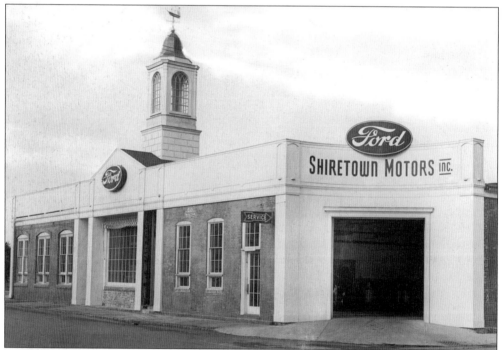

**SHIRETOWN MOTORS, ON THE CORNER OF WATER AND UNION STREETS, C. 1950.** The building was part of the Plymouth Foundry, where stoves and cast-iron utensils were made from the 1840s to 1935. Plymouth is the "shire town," or county seat, of Plymouth County.

40

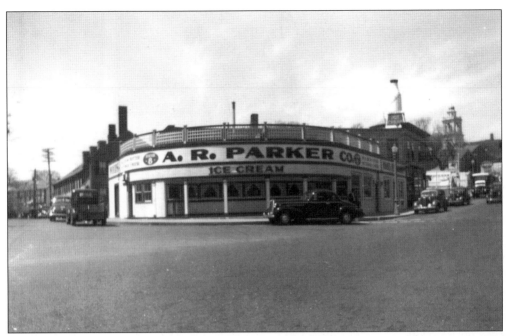

**A.R. PARKER ICE CREAM, ON THE CORNER OF MARKET STREET AND MAIN STREET EXTENSION, 1940.** This was the Old Colony Dairy Bar earlier but is now just a grassy bank across from Friendly's restaurant on Sandwich Street.

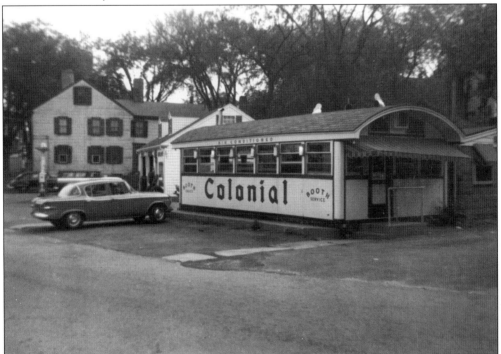

**THE COLONIAL DINER, AT 19 SANDWICH STREET, 1963.** This is now the site of the Friendly's parking lot. The gas station behind it is now the Mayflower Realty building. The house on the left was razed to gain access to the lot behind.

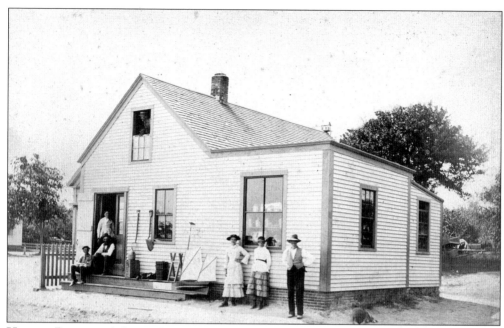

HARVEY BARTLETT'S JABEZ CORNER GENERAL STORE, AT 233 SANDWICH STREET, C. 1880.
Bartlett's wife, Nancy, is standing in the doorway, and her son Ansel is sitting on the step.
Harvey Jr. is in the upper window. The store, which was on land bought by Jabez Churchill Jr.,
passed to Ansel and then to his nephew Guy Cooper. It is now a 7-11.

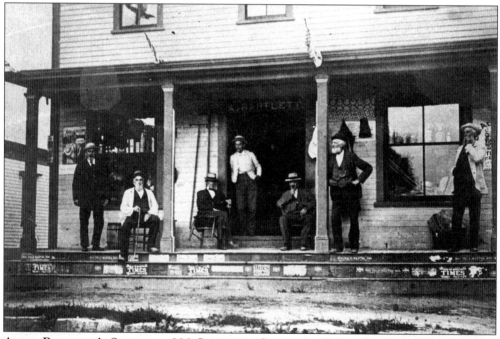

ANSEL BARTLETT'S STORE, AT 233 SANDWICH STREET ON JABEZ CORNER, 1892. From left
to right are Capt. Ben Sears, Capt. Wellington Lamberton, Lionel Churchill, Guy Cooper,
Lemuel Howland, Ansel Bartlett (owner of the store), and Sam B. Holmes. Bartlett's nephew
Guy Cooper inherited the store in 1903. The Wellingsley school is on the left.

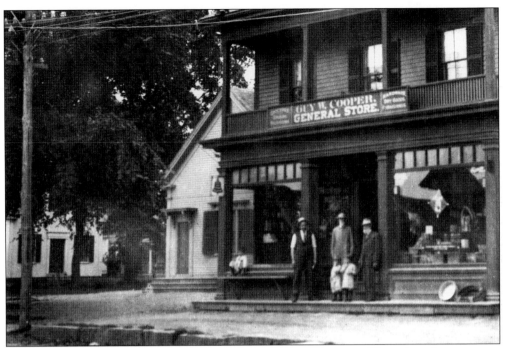

GUY COOPER'S GENERAL STORE, AT 233 SANDWICH STREET, 1909. The enlarged store is seen with, from left to right, Guy Cooper, an unidentified man, and Thomas Sears and his twin granddaughters. The Wellingsley Union Chapel is on the far left in this view, and the Wellingsley School is in the center.

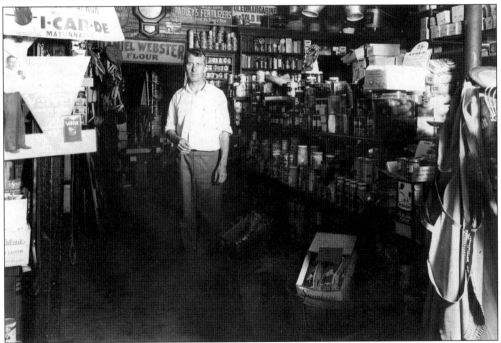

THE INTERIOR OF GUY COOPER'S STORE, 1932. Howard Haire was Cooper's nephew and worked in the store for a number of years.

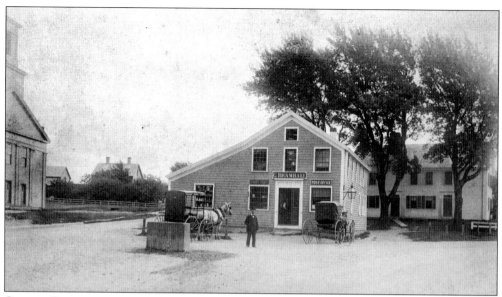

**GEORGE BRAMHALL AND HIS GENERAL STORE, ON BRAMHALL'S CORNER, C. 1890.** The heart of Chiltonville is at the fork of River Street (left) and Sandwich Road (right). Chiltonville Church and the Nickerson House are on the left. The store looks today almost the same as it does here, but it is only open in the summer. The Bramhall house (right), on the old church lot, was later removed.

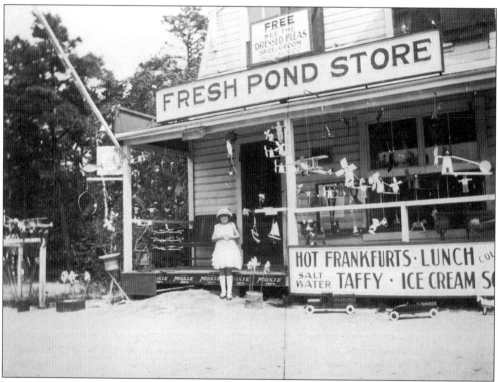

**FRESH POND STORE IN MANOMET, 1925.** There was a public campground at Fresh Pond, which was at the end of the street railway line and remained a popular resort for summer visitors.

## Four

# THE TOURIST TOWN AND SUMMER VISITATION

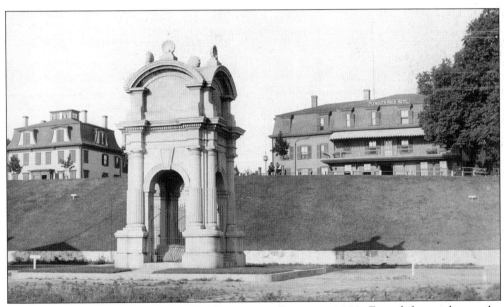

COLE'S HILL AND THE CANOPY OVER PLYMOUTH ROCK, C. 1890. From left to right are the Holmes House, Plymouth Rock, and the Plymouth Rock Hotel. The large linden tree, as a sapling, had been pulled up following a failed engagement in 1809. Casually replanted by William Davis, it flourishes today.

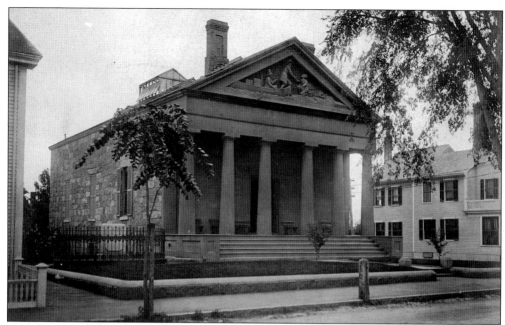

PILGRIM HALL, AT 75 COURT STREET, C. 1900. This view shows the hall, built in 1824, before the library wing was added in 1904. The portico and pediment figures are of wood. The present granite portico was added in 1921.

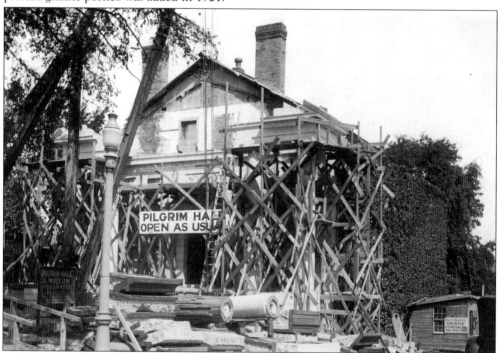

CONSTRUCTING THE GRANITE PORTICO AT PILGRIM HALL, AUGUST 25, 1921. When Pilgrim Hall was built of granite in 1824, the Pilgrim Society could not afford to build the Doric portico in stone, and a wooden one was installed. The new construction was underwritten by the New England Society of New York for the 1920–1921 tercentenary.

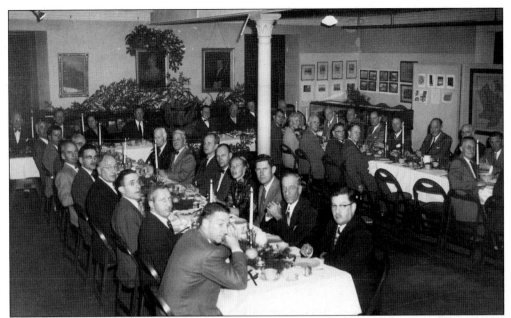

**A PILGRIM SOCIETY FOREFATHERS' DAY DINNER IN THE LOWER HALL AT PILGRIM HALL, DECEMBER 21, 1953.** This dinner revived the convivial 19th-century celebration of the anniversary of the landing of the Pilgrims, which has been held each year since. Rose Briggs presented a paper on the history of Plymouth Rock.

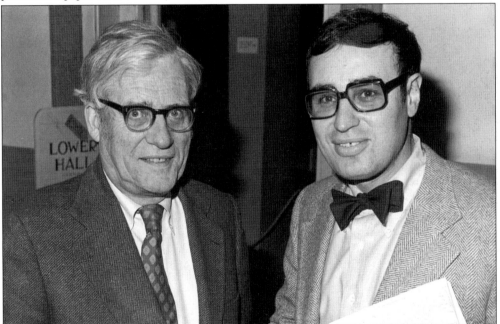

**HENRY HORNBLOWER II AND LAWRENCE W. GELLAR DURING THE OPENING OF THE *REMEMBER THE LADIES* EXHIBIT AT PILGRIM HALL, 1970.** Harry Hornblower was the founder of Plimoth Plantation in 1947, which had begun as a Pilgrim Society project in 1945. Larry Gellar, then the new Pilgrim Hall director, would bring the nation's oldest historical museum into modern times.

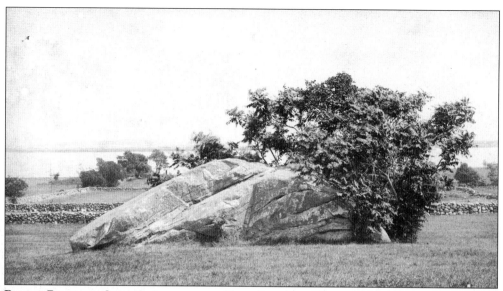

**PULPIT ROCK ON CLARK'S ISLAND IN A VIEW LOOKING WEST, 1893.** Tradition states that the advance party from the *Mayflower* held a Sunday service here on December 9, 1620, before landing on Plymouth Rock the following day. The island was a popular place for picnics and Election Day celebrations.

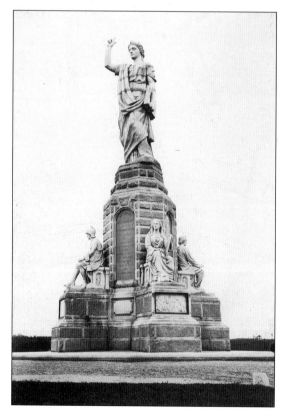

**THE FOREFATHERS' MONUMENT ON ALLERTON STREET IN A VIEW LOOKING NORTHWEST, C. 1885.** Designed by Hammatt Billings of Boston for the Pilgrim Society, the monument to the forefathers (Pilgrims) was begun in 1859. Financing proved a problem during the Civil War, so the 81-foot granite structure was not completed until 1889.

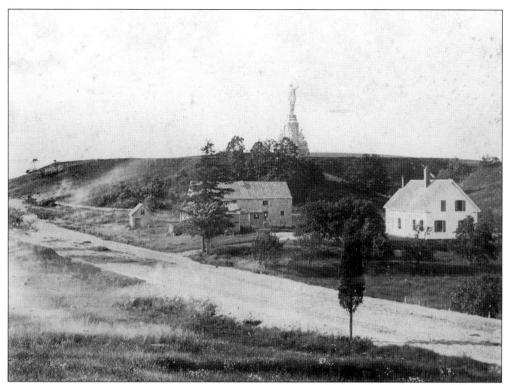

THE FOREFATHERS' MONUMENT IN A VIEW LOOKING NORTH FROM STANDISH AVENUE, c. 1890. The Pilgrim monument is the tallest freestanding granite statue in the world. Note the lack of vegetation on the hill, which is heavily forested today.

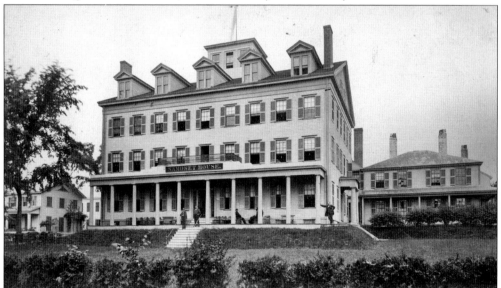

THE SAMOSET HOUSE, ON THE CORNER OF COURT AND SAMOSET STREETS, c. 1880. Built in 1846 by the Old Colony Railroad, the Samoset House was Plymouth's first hotel and was very popular with summer visitors and local parties. The Samoset House burned down in 1939, and the site is now occupied by Papa Gino's.

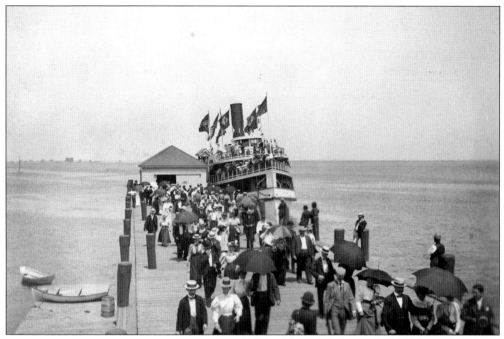

"TOURISTS ARRIVING ON THE BOSTON BOAT," AT LONG WHARF, 1900. The availability of inexpensive transport in the form of electric streetcars and steamboats in the 1890s attracted many day-trippers and working-class families to Plymouth.

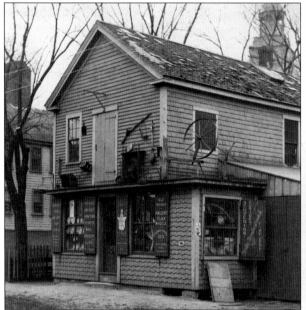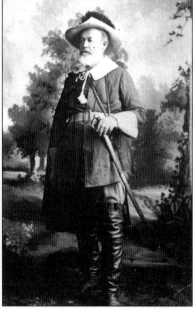

LEFT: THE OLD CURIOSITY SHOP, ON WATER STREET, IN A VIEW LOOKING SOUTHWEST, 1900. RIGHT: WINSLOW BREWSTER STANDISH, C. 1890. Winslow Brewster Standish kept Plymouth's second antique shop in the former ship's chandlery. The building was the last surviving house on Water Street before it was demolished before the 1921 Pilgrim tercentenary. The Drew House is on the left, and the Universalist church steeple can be seen behind the shop.

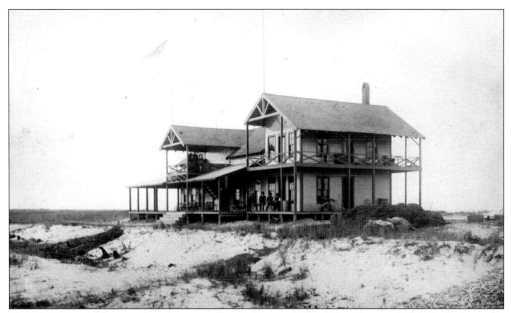

**THE PLYMOUTH BEACH ASSOCIATION PAVILION, C. 1883.** The Plymouth Beach Association Pavilion opened in July 1883 and was reached by a small steamer, the *Modoc*, which crossed Plymouth Harbor on a regular schedule. The walkway led to the harbor pier where the steam launch brought passengers to and from town.

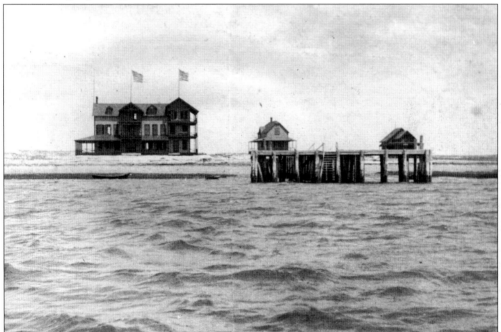

**THE COLUMBUS PAVILION AND PIER, C. 1895.** The Columbus Pavilion and Pier is located on the inner side of Plymouth Beach, about opposite the turn of the channel. The pavilion was bought by Charles L. Willoughby of Chicago in 1890, and a third floor was added. A popular local resort hosting dances and serving "shore dinners" (a sort of indoor clambake), it was swept away in the Portland Gale of November 1898.

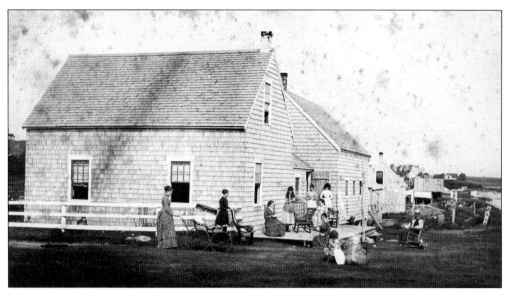

**THE TURNER COTTAGE, AT THE HEAD OF PLYMOUTH BEACH, AUGUST 1884.** This view of the Turner Cottage shows members of the Atwood, Baker, and Brewster families. The cottage was about where the Pilgrim Sands Motel is today.

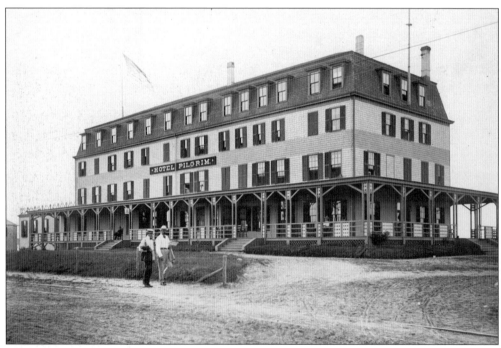

**THE HOTEL PILGRIM, ON WARREN AVENUE, C. 1890.** Opened in 1857 as the Clifford House on the hill overlooking Plymouth Beach, the hotel was bought by the Brockton and Plymouth Street Railway in 1891 and renamed the Hotel Pilgrim. The hotel was renovated in the Colonial Revival style in 1903. It closed in the 1950s.

**WHITE HORSE ROCK, C. 1900.** White Horse Beach became a popular summer resort for families from South Boston and Dorchester following the introduction of the street railway.

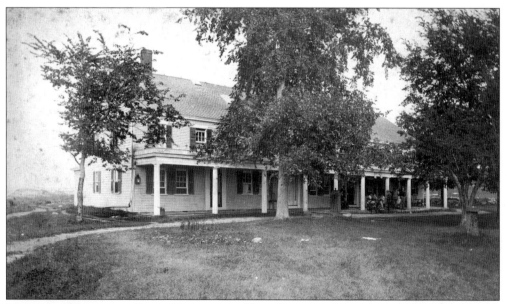

**MANOMET HOUSE, ON POINT ROAD, IN A VIEW LOOKING SOUTH, C. 1890.** This popular early hotel, later called the Ardmore Inn, was on the road below where the Mayflower Hotel was built in 1916.

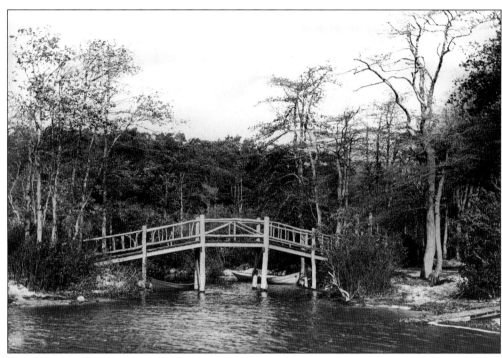

**THE RUSTIC BRIDGE AT THE SOURCE OF TOWN BROOK, BILLINGTON SEA, IN A VIEW LOOKING EAST, C. 1900.** The bridge was installed as part of the new Morton Park, where there is a much more modest bridge today.

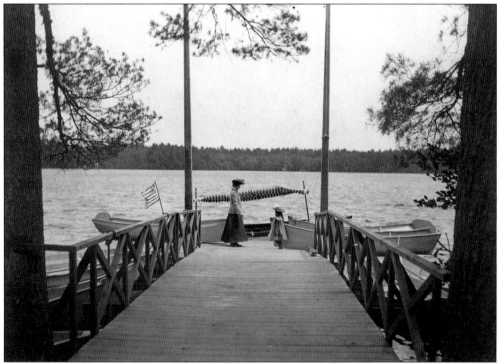

**THE PIER AT MORTON PARK, BILLINGTON SEA.** This view was taken *c.* 1900.

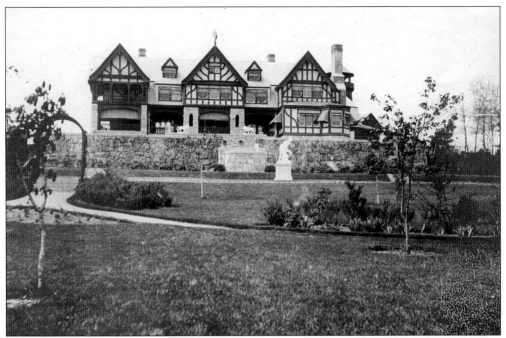

CHILTON HALL, ON JORDAN ROAD, C. 1895. This imposing structure, known locally as "the Castle," was built by Eben Jordan Jr. of Jordan Marsh Company in 1895. Designed in the Tudor style, the summer home had 23 bedrooms and 13 baths. It was razed in the 1930s.

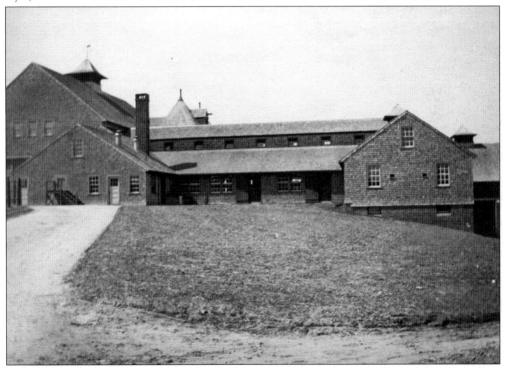

FORGES' BARN, OFF JORDAN ROAD IN CHILTONVILLE, IN A VIEW LOOKING WEST, C. 1920. The barn was part of the Jordan Estate, which was sold to Sherman Whipple in 1910.

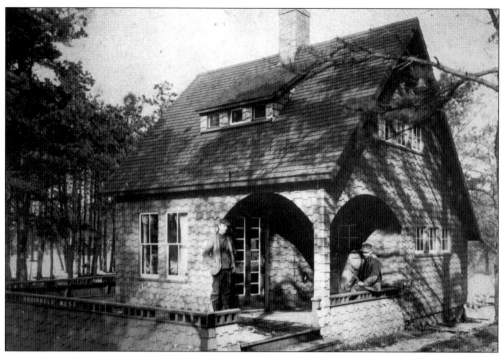

SQUIRREL'S NEST COTTAGE, ON BOOT POND, IN A VIEW LOOKING NORTHWEST, C. 1890. Guy W. Cooper (standing) and Samuel L. Gleason are seen in this view. Built cooperatively in 1893 by five friends, the cottage has been enlarged as a private home.

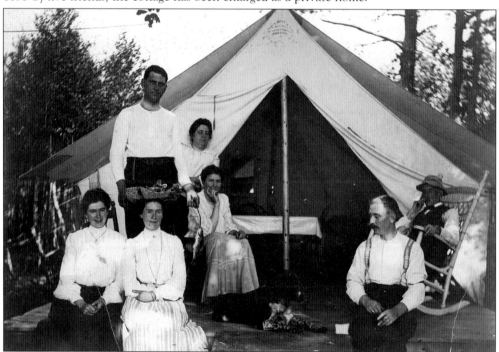

CAMPING ON GREAT SOUTH POND, C. 1890. Mr. and Mrs. Will Snow and friends are seen in this view.

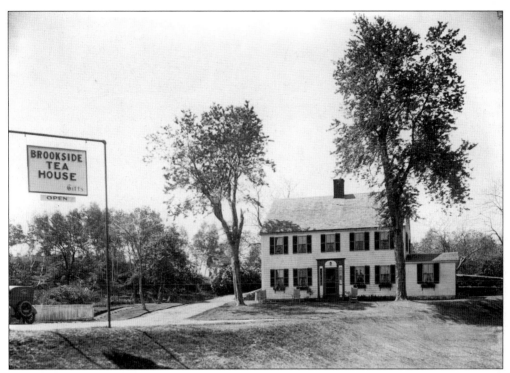

THE BROOKSIDE TEA HOUSE, AT 601 STATE ROAD IN MANOMET, C. 1925. Located next to Beaver Dam Brook, the site is now occupied by Fishbones' Grill.

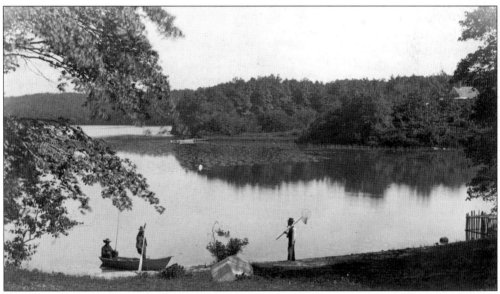

LITTLE LONG POND IN A VIEW LOOKING NORTH, C. 1895. At this time, summer visitors were discovering the attractions of Plymouth's large ponds. Old farms, pastures, and wood lots were bought by families from Boston and developed into large private vacation estates.

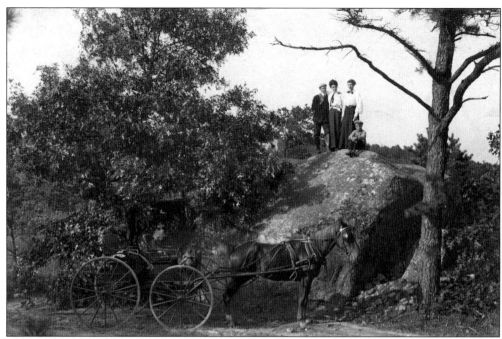

**CLEFT ROCK, AT THE CREST OF THE PINE HILLS OFF STATE ROAD IN MANOMET, C. 1900.** This photograph was taken by Ed Hoxie. The boulder was a local landmark, and postcards were sold of it. It is still a town park today, with picnic tables and nature trails.

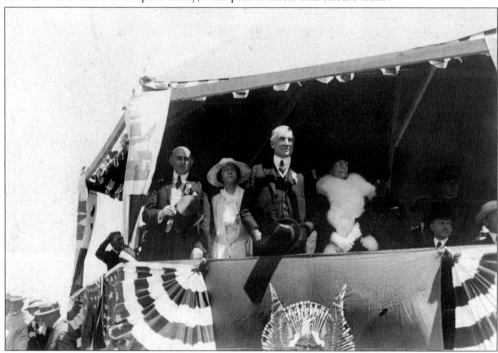

**PRES. WARREN G. HARDING AT THE PILGRIM TERCENTENARY PAGEANT, *THE PILGRIM SPIRIT*, AUGUST 1, 1921.** From left to right are Governor Cox, Mrs. Coolidge, President Harding, Mrs. Harding, Mr. Kyle, and Senator Lodge.

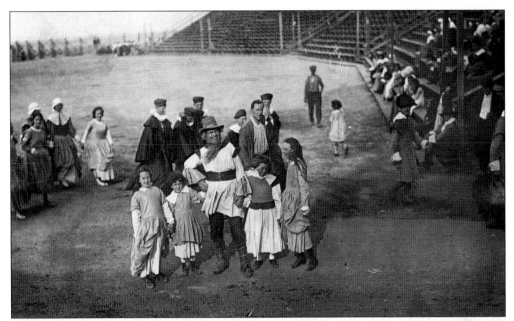

**A Scene from *The Pilgrim Spirit*, Summer 1921.** This immense pageant, written and directed by George P. Baker, told the story of Plymouth and the Pilgrims from the time of the Vikings to the trial of Lyford and Olham in 1624, employing 1,300 costumed players and a chorus of 300. Some 110,000 people saw the production.

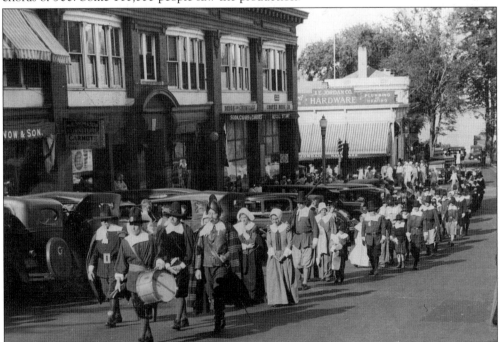

**The Pilgrim Progress at the Plymouth Town Square, c. 1930.** This parade commemorating the Pilgrims' march to worship has been held on Fridays in August since 1921 and on Thanksgiving Day as well. Generations of Plymoutheans have donned well-used Pilgrim garb to take part in the traditional 51-person march from Cole's Hill to Burial Hill.

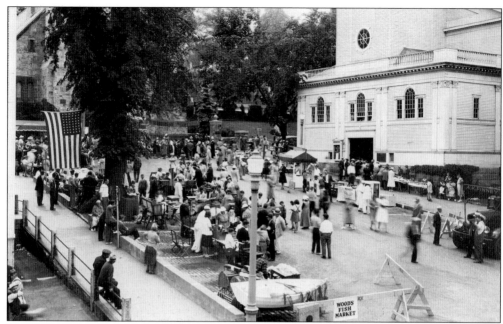

THE 301ST ANNIVERSARY MARKET-FAIR, AT THE PLYMOUTH TOWN SQUARE, JUNE 15, 1940. This civic fair was an effort to capitalize on the interest in "Colonial" arts and crafts. Stalls included candle dipping, pewter casting, weaving, pottery, hooked rugs, and displays of local industries, such as fishing and cranberrying. Activities also included folk dancing.

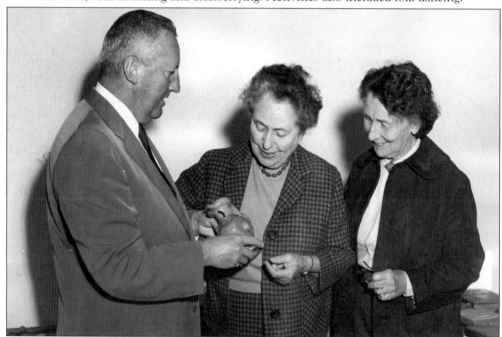

CHARLES R. STRICKLAND, ROSE T. BRIGGS, AND RUTH GARDNER STEINWAY, C. 1960. Strickland (restorer of the Howland and Sparrow Houses and architect for Plimoth Plantation), Briggs (director of Pilgrim Hall and later president of the Plymouth Antiquarian Society), and Steinway were at the center of Plymouth's historical establishment in the mid-20th century.

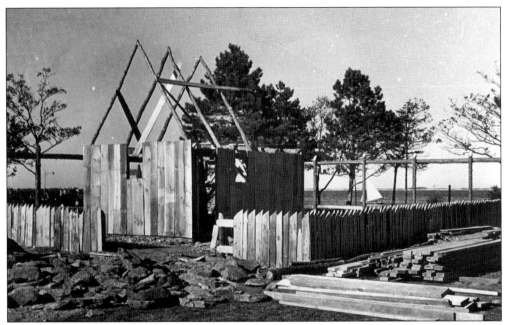

CONSTRUCTING PLIMOTH PLANTATION'S FIRST HOUSE, ON WATER STREET, 1948. The small, thatched timber-frame structure, designed by Charles R. Strickland, was erected near Plymouth's state pier to advertise (and gauge public support for) the proposed Plimoth Plantation open-air museum. It was an immediate success with 300,000 visitors in 1949.

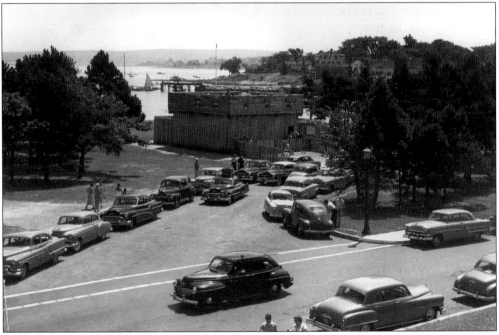

THE PILGRIM FORT/MEETINGHOUSE, SOUTH OF PLYMOUTH ROCK ON WATER STREET, c. 1955. Built by Plimoth Plantation in 1953, the Pilgrim Fort/Meetinghouse was moved to the Eel River site in 1958, where Plimoth Plantation is today. It was replaced with the present Pilgrim Fort/Meetinghouse in 1988.

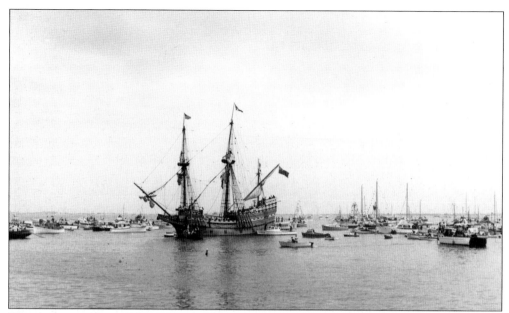

**THE ARRIVAL OF THE *MAYFLOWER II*, JUNE 13, 1957.** Built in Brixham, England, and sailed across the Atlantic by Alan Villiers and his hand-picked crew, the *Mayflower II* was welcomed by enormous crowds and Vice Pres. Richard Nixon. Ownership of the ship was assumed by Plimoth Plantation the following year.

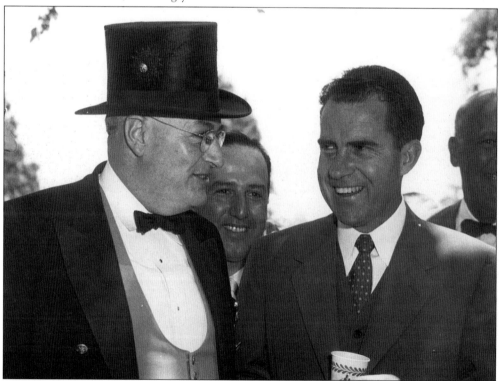

**THE OLD COLONY CLUB PRESIDENT AND VICE PRES. RICHARD NIXON, 1957.** The Old Colony Club president Sheriff Adnah Harlow chats with Nixon at the arrival of the *Mayflower II*.

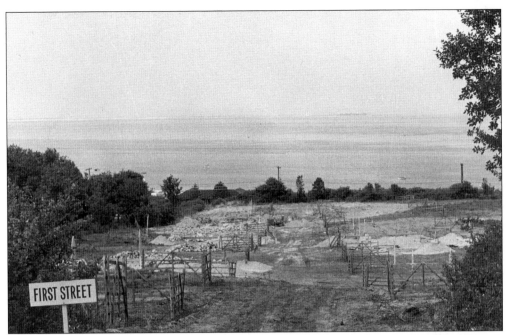

LOTS MARKED OUT FOR PLIMOTH PLANTATION'S "FIRST STREET," 1958. Plimoth Plantation received this property for the Pilgrim Village re-creation through a bequest from Hattie F. Hornblower, grandmother of museum founder Henry Hornblower II, in 1955. Hattie Hornblower had acquired the Eel River property in 1898.

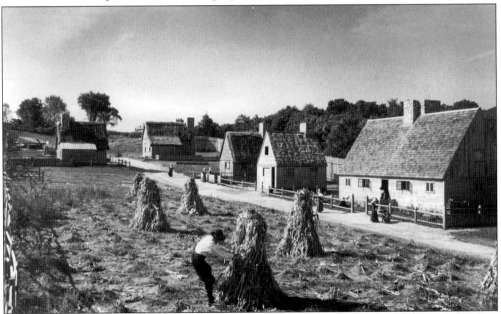

AN AUTUMN IDYLL, AT PLIMOTH PLANTATION, 1959. This popular picture shows the Pilgrim Village in its second year of operation. The houses, designed by Charles R. Strickland, represent, from left to right, the Brewster, Bradford, Howland, Fuller, and Warren family homes. A corner of the Pilgrim Fort/Meetinghouse, moved from the waterfront in 1958, can be seen to the left of the Bradford House.

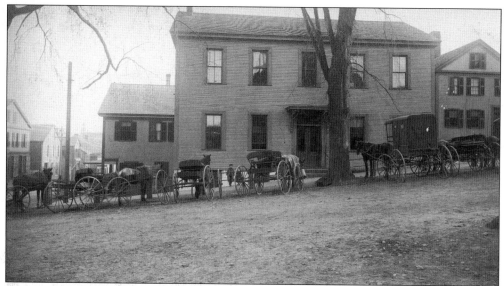

THE PLYMOUTH TOWN HOUSE, IN THE PLYMOUTH TOWN SQUARE, C. 1890. The building was the seat of town government from 1820 to 1953. Saved from demolition and restored in 1970, it is now the 1749 Courthouse Museum. Visitors may see the re-created Colonial courtroom and exhibits of Plymouth history free of charge.

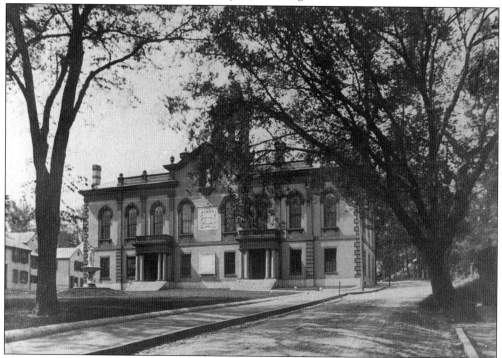

THE 1820 PLYMOUTH COUNTY COURT HOUSE, ON COURT STREET, 1880. The Plymouth County Court House was noted as a particularly fine example of architecture. Note the two-toned painted exterior, which was added during the renovations of 1857 but was lost in the fire of 1881. The houses on South Russell Street on the left were backed on to Burial Hill; they were removed *c.* 1930.

# Five

# PLYMOUTH PUBLIC
# BUILDINGS AND EVENTS

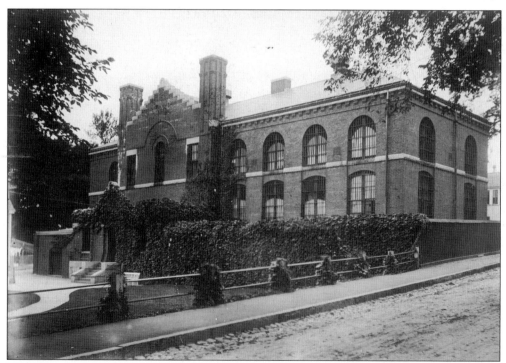

**THE PLYMOUTH HOUSE OF CORRECTION, NORTH RUSSELL STREET, C. 1890.** The nearby old stone jail built in 1820 was superceded by this building in 1852. Today, the Colonial records and county archives are stored here, and there are offices and a law library on the upper floors.

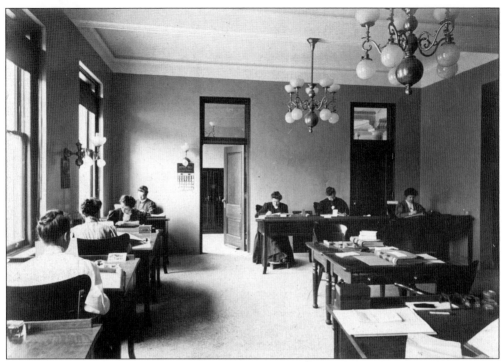

THE INTERIOR OF THE PLYMOUTH COUNTY REGISTRY OF DEEDS, NORTH RUSSELL STREET, c. 1905. The registry and probate court building was built in 1904 and, though antiquated and overcrowded, is still in service.

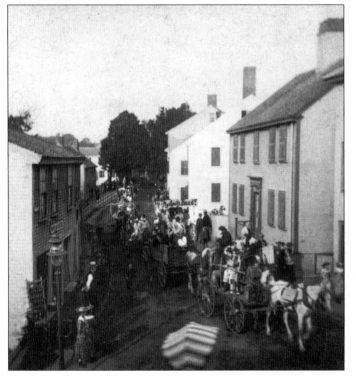

THE ANCIENT AND HORRIBLES FOURTH OF JULY PARADE, ON SUMMER STREET, 1883. The parade, which was put on by the Plymouth Police and Protective Association, gathered on Railroad Avenue at 5 a.m. and took a circuitous route around the town before ending in Shirley Square, where the Plymouth Band gave a concert. There was a fireworks display that night on "New Water Street" at the foot of Chilton Street.

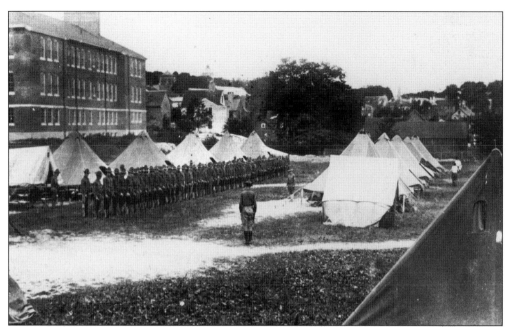

**COMPANY D, 5TH REGIMENT MASSACHUSETTS INFANTRY, 101ST REGIMENT (YANKEE DIVISION).** Company D camped behind the Nathaniel Morton School in 1917. This is a view looking northwest from near Lincoln Street.

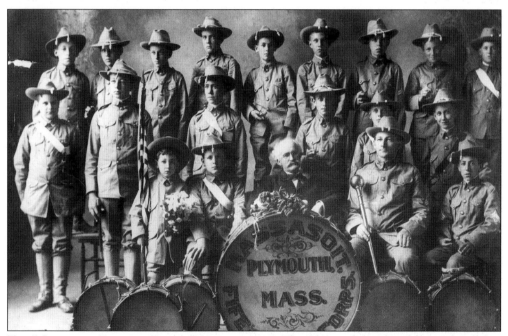

**THE MASSASOIT FIFE AND DRUM CORPS, C. 1905.** This Plymouth boy band was embroiled in a union dispute on July 4, 1905, in Rockland, Massachusetts, where they had been invited to play in the annual parade. Refusing to withdraw, the Massasoit Fife and Drum Corps marched under the protection of 5 sheriffs and 15 constables. The corps was organized and led by Plymouth shoemaker Geoffrey D. Perrior.

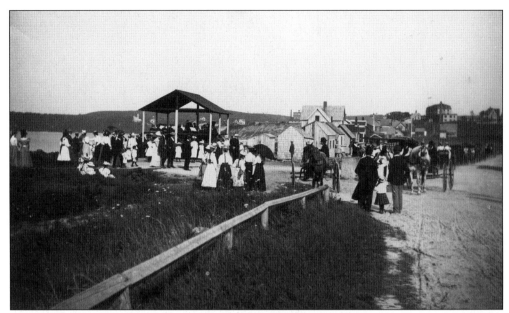

**A Band Concert, at the Head of Plymouth Beach on Warren Avenue, c. 1890.** The Hotel Pilgrim can be seen on the crest of the hill to the right.

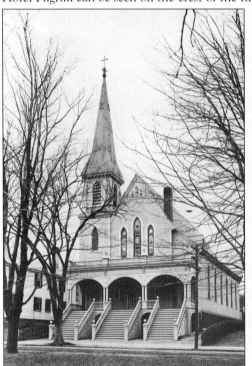
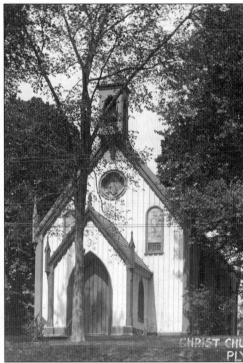

*Left:* St. Peter's Catholic Church, on Court Street, c. 1900. *Right:* The First Church Episcopal, at 29 North Russell Street, 1906. St. Peter's was dedicated in 1879. The handsome wooden porch was later replaced with a cement stairway. Christ Church Episcopal was built in 1846. It was sold in 1915, following the congregation's move to the present building on the corner of Lothrop and Court Streets *c.* 1911.

**THE UNIVERSALIST CHURCH, ON CARVER STREET, C. 1932.** The church is seen in this view from Brewster Gardens. The church was torn down in 1934.

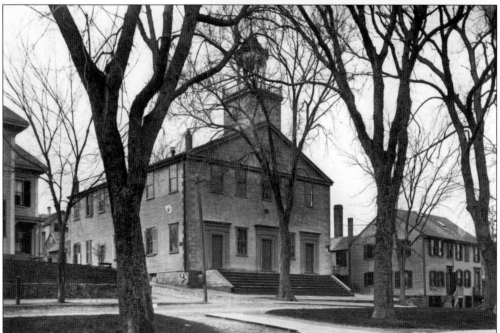

**PLYMOUTH HIGH SCHOOL, ON THE CORNER OF WASHINGTON AND PLEASANT STREETS, C. 1890.** Built as the Third Parish Church in 1803, the building was abandoned following the construction of the Church of the Pilgrimage in the Plymouth Town Square in 1840. It served as the high school from 1850 until the new building on Lincoln Street was opened in 1892, and this structure was demolished.

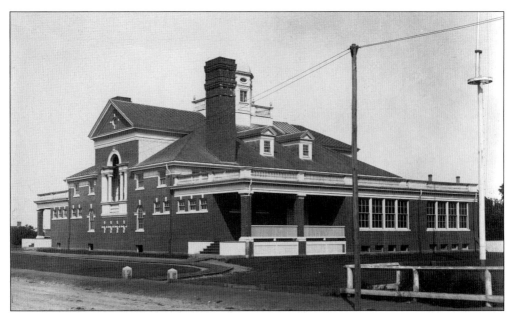

**PLYMOUTH HIGH SCHOOL, AT 11 LINCOLN STREET, IN A VIEW LOOKING SOUTHEAST, 1891.** The building superceded the old building on Pleasant Street, costing $40,000, and had 200 students in 1892. This school was replaced in turn by another high school on the other side of Lincoln Street (1930–1963). Remodeled and enlarged, it has been the Plymouth seat of local government since 1953.

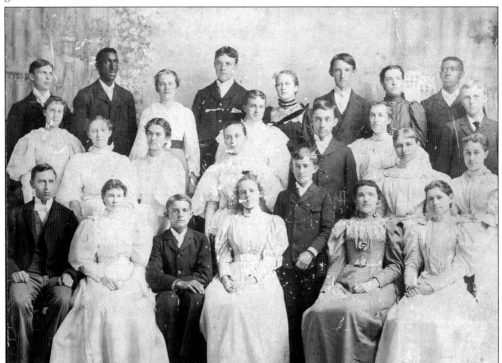

**A PLYMOUTH HIGH SCHOOL CLASS.** This image shows the Plymouth High School Class of 1895.

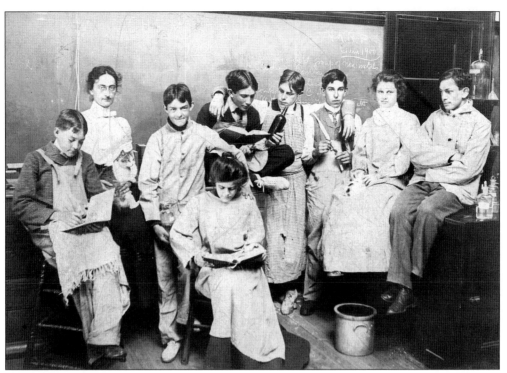

**A PLYMOUTH HIGH SCHOOL CHEMISTRY CLASS, C. 1900.** The high school was located at 11 Lincoln Street at the time of this photograph.

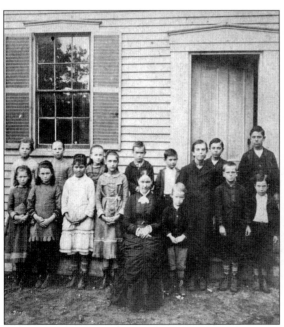
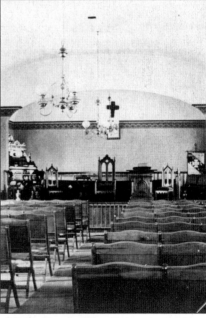

**LEFT: A CLASS OF THE RUSSELL MILLS SCHOOL, C. 1878. *RIGHT:* THE INTERIOR OF THE METHODIST CHAPEL, C. 1900.** From a stereopticon view, this class can be seen with its teacher, Mary A. Morton. The Methodist chapel was located at Russell Mills in Chiltonville.

THE CHILTONVILLE CHURCH, RIVER STREET WITH CEMETERY AND EBEN NICKERSON'S ORCHARD, C. 1880. This view of the church is looking northeast. Note the carriage shed to left of church.

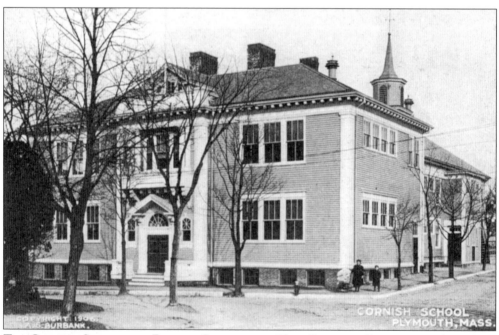

THE CORNISH SCHOOL, ON RUSSELL STREET, IN A VIEW LOOKING SOUTH FROM ALLERTON STREET, 1960. The school, which many contemporary Plymoutheans attended in their youth, was built in 1840. The school building was torn down by the Plymouth Urban Renewal Authority in the mid-1960s, and the site was used by the police department before they moved to Long Pond Road.

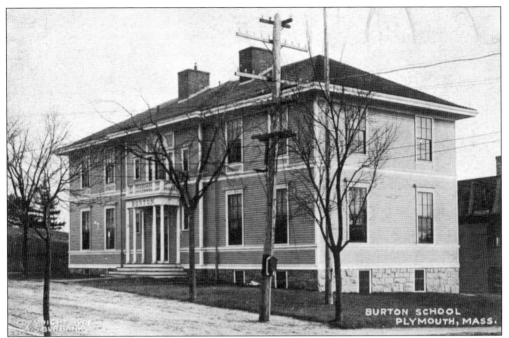

THE BURTON SCHOOL, ON RUSSELL STREET, IN A VIEW LOOKING SOUTHEAST FROM ALLERTON STREET, C. 1900. This school, located just west of the Cornish School, was built in 1896. It was named for Charles Burton, Plymouth's school superintendent for 35 years. The site has been a parking lot since c. 1965.

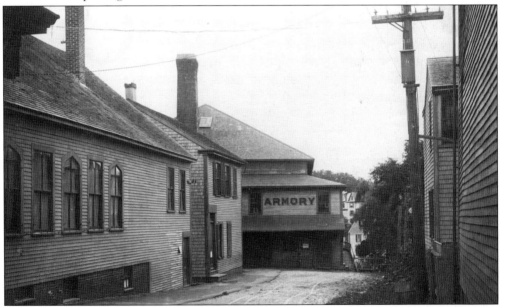

THE STANDISH GUARDS ARMORY ENTRANCE, OFF LEYDEN STREET, C. 1895. This building housed many social entertainments, including bowling, band concerts, and roller-skating. The 1896–1897 Old Plymouth Days and Ways pageant was held here for the First Parish Church, which burned in 1892. The new armory on Court Street was built in 1906, and this building was demolished in 1908.

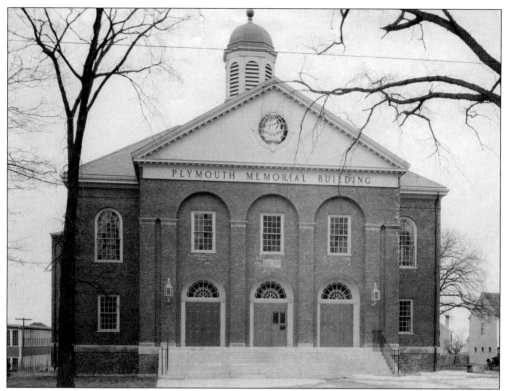

THE PLYMOUTH MEMORIAL HALL, AT 83 COURT STREET, 1927. Built as a memorial to Plymouth men who served in all wars and a meeting place for large groups, the Plymouth Memorial Hall was begun on December 21, 1924, and dedicated on April 19, 1926. It is now undergoing renovations.

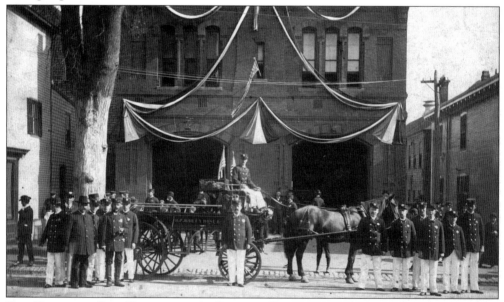

THE PLYMOUTH FIRE DEPARTMENT'S CENTRAL STATION, AT 51 MAIN STREET, C. 1889. This site is now Sam Diego's Mexican Restaurant.

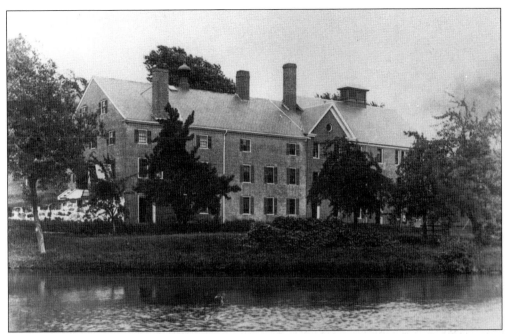

**The Poorhouse in a View Looking Southeast across Poorhouse, or Alms House, Pond, c. 1890.** Built in 1826, the large brick building housed an average of 33 people through the 19th century and was still in operation in the early 1950s. It was demolished by the Plymouth Urban Renewal Authority in the mid-1960s. Today, the area is a public park.

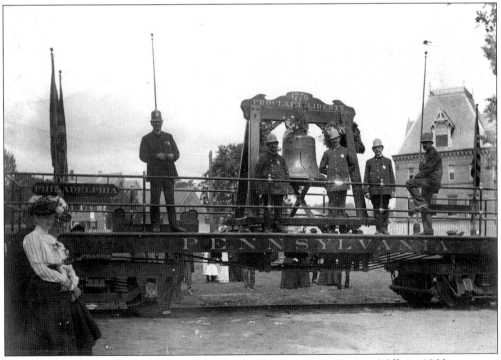

**The Liberty Bell.** The Liberty Bell is on its railway car near Puritan Mills in 1903.

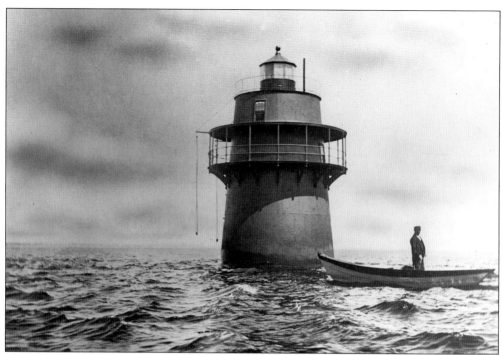

**BUG LIGHT (DUXBURY PIER LIGHT), AT THE ENTRANCE TO PLYMOUTH HARBOR, C. 1890.**
The lighthouse was installed in 1871 and is still in operation today.

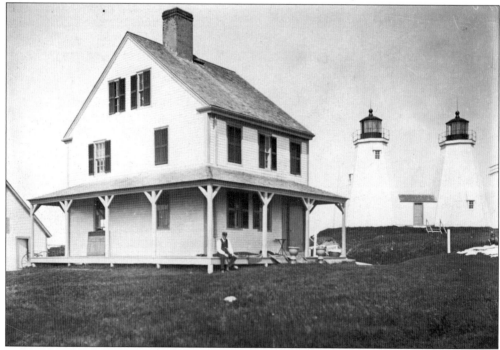

**GURNET LIGHT AND LIGHTKEEPERS' HOUSE, C. 1890.** The double wooden lighthouse was built in 1803, replacing an earlier structure built in 1768, which had burned in 1801. Only one light survives today, the second having been removed in 1926.

# Six

# PLYMOUTHEANS AT HOME, AT WORK, AND AT PLAY

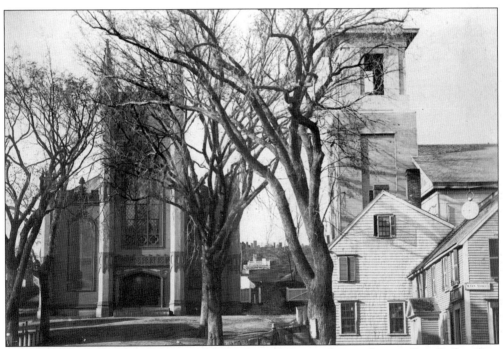

**THE PLYMOUTH TOWN SQUARE, C. 1870.** From left to right are the wooden Gothic First Parish Church (1831–1892); the Third Church (Church of the Pilgrimage, 1840); and the Town Tree (with notice board), where official announcements were posted. The Town Tree blew down and killed a woman in 1885. The old Bradford house and the post office were torn down to build the Odd Fellows hall (1877–1904).

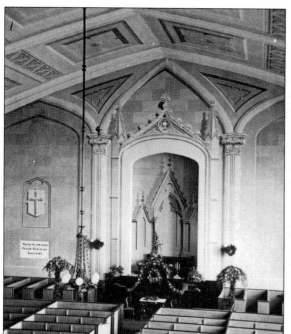

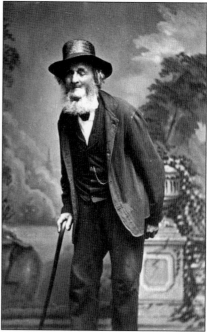

LEFT: THE INTERIOR OF THE FIRST PARISH CHURCH BEFORE THE FIRE OF 1892. RIGHT: CLEMENT BATES (1793–1885). Clement Bates, sexton of First Parish Church from 1831 until his death, took care of the Plymouth Town House and rang the town bell at appointed times—7 a.m., 12 p.m., 1 p.m., and 6 p.m. He would ring it at 5 p.m. on Saturdays and at 9 p.m. for curfew. Bates also conducted all funerals before private undertakers became common.

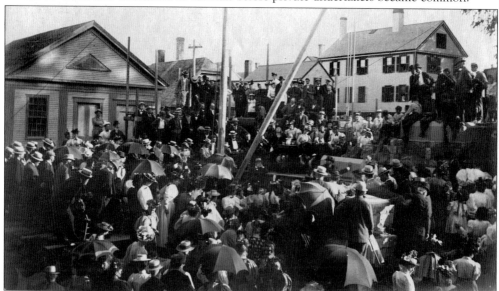

LAYING THE CORNERSTONE OF THE PRESENT FIRST CHURCH (UNITARIAN-UNIVERSALIST), IN THE PLYMOUTH TOWN SQUARE, JUNE 29, 1896. The earlier wooden structure burned down in December 1892. The building on the left is the Old Chapel, which had been moved from just west of the Church of the Pilgrimage. It became part of the First Church Parish Center following the "renewal" of Church and High Streets.

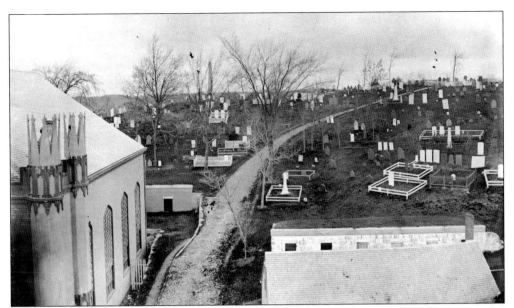

A View of Burial Hill from the Steeple of the Church of the Pilgrimage, c. 1870.
The wooden Gothic First Parish Church (1831–1892) is on the left. The building in the
foreground was the Central School from 1756 to 1840, when the Cornish School was built on
Russell Street.

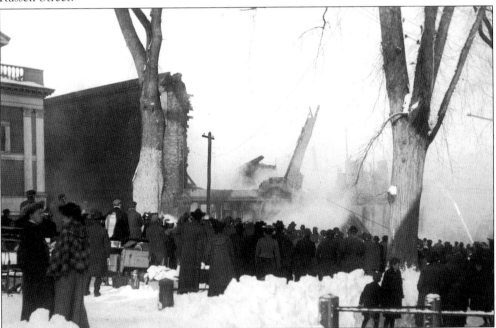

The Odd Fellows Building Fire on Main Street in a View Looking Northwest,
January 9, 1904. The Odd Fellows hall was built on the site of Governor Bradford's house on
the Plymouth Town Square. Public events were held upstairs in Adelphian Hall. The Governor
Bradford building, which replaced the Odd Fellows building, had a drugstore on the ground
floor (Cooper's Drug, Pilgrim Drug, and CVS) for almost a century until M & M Sporting
Goods moved there in 2001.

LEYDEN STREET IN A VIEW LOOKING EAST, C. 1890. This street was Plymouth's first street, laid out in 1620. The Barnabas Hedge House is on the left. Across the street are Chandler Robbins's parsonage (with a central door) and General Goodwin's house (right). The street received the name Leyden Street in 1823.

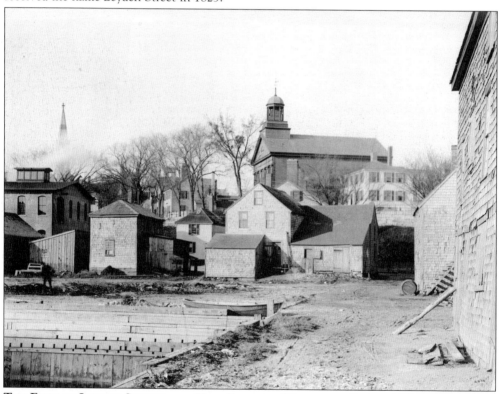

THE FOOT OF LEYDEN STREET IN A VIEW LOOKING WEST FROM BARNES' WHARF, C. 1890. All of the buildings below Cole's Hill were removed before 1920, except for the Plymouth Electric Company (brick building on the left).

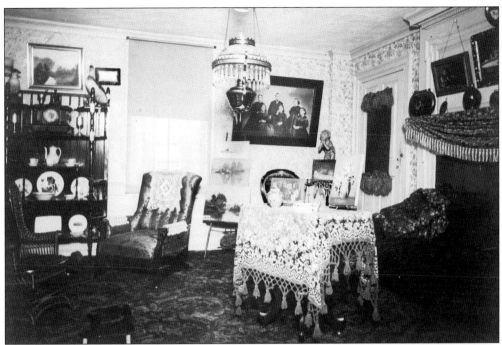

**Mrs. Thomas Diman's Parlor, at 21 Leyden Street.** The parlor is shown here c. 1895.

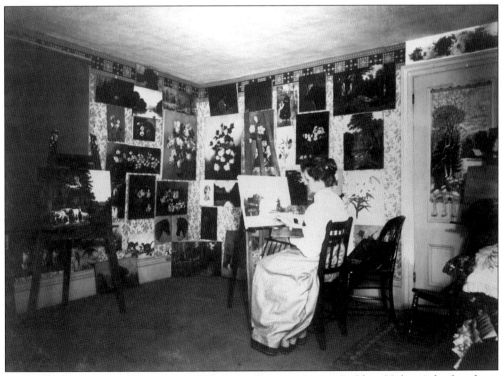

**Olive Holmes in her Studio, at 25 Leyden Street, c. 1895.** Olive Holmes's husband was a carriage painter.

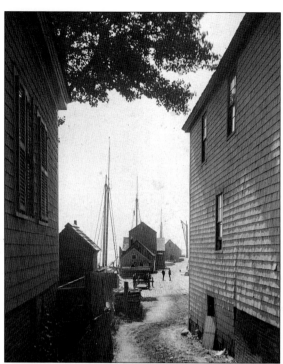

**AN ALLEY LEADING TO BARNES' WHARF, C. 1890.** This alley was located at the foot of Leyden Street.

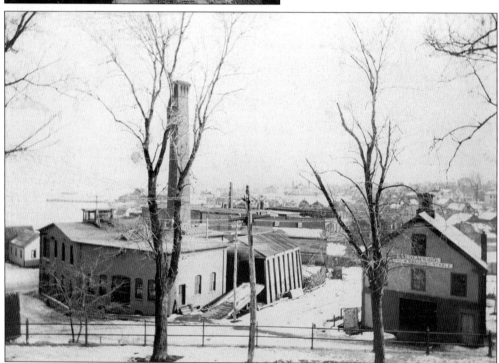

**THE PLYMOUTH ELECTRIC COMPANY POWER PLANT, ON THE CORNER OF LEYDEN AND WATER STREETS, C. 1915.** The Blackmer Stables were torn down in 1919, and a replica Pilgrim log cabin was built for the 1921 tercentenary. The last of the electric company building was removed in 1960. This view looks south from Carver Street.

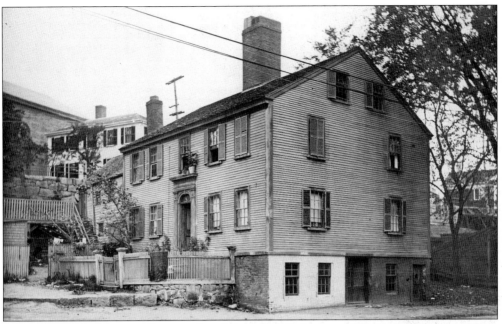

THE DREW HOUSE, AT 16 LEYDEN STREET ON THE CORNER OF WATER STREET, IN A VIEW LOOKING WEST TOWARD COLE'S HILL. This part of the hill was filled in and grassed over for the 1920–1921 tercentenary. Note the white house on the left, which is today next to the Salvation Army church on Carver Street.

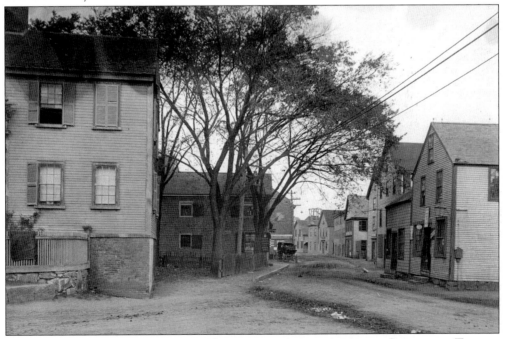

WATER STREET IN A VIEW LOOKING NORTH FROM ABOUT WHERE THE SOUTHERLY TRAFFIC CRESCENT ENTRANCE IS TODAY, C. 1890. The buildings on the left, built into Cole's Hill, were bought by the Pilgrim Society and demolished after 1895. All the buildings here, including the Plymouth Rock portico, were gone by 1920.

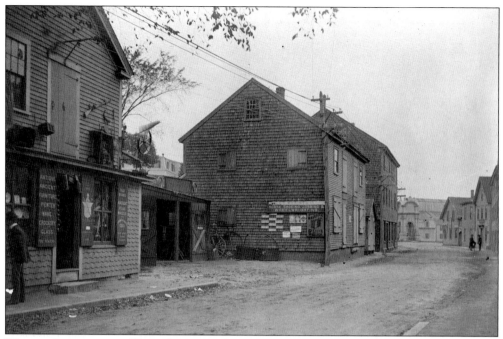

WATER STREET IN A VIEW LOOKING NORTH FROM THE CORNER OF LEYDEN STREET, c. 1890. W.B. Standish's antique store, the Old Curiosity Shop, is just behind the second tree, and Plymouth Rock is just beyond the last house visible on the east (right) side of the street.

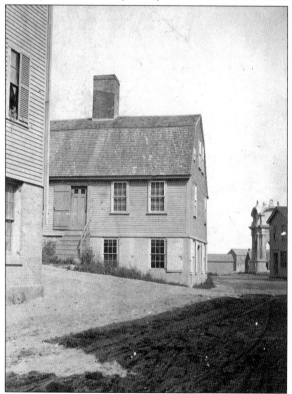

AN OLD HOUSE ON WATER STREET BELOW MIDDLE STREET, c. 1880. Owned by William H. Nelson, this house was apparently later reerected on the 1699 Winslow House lot in Marshfield at the time of the tercentenary.

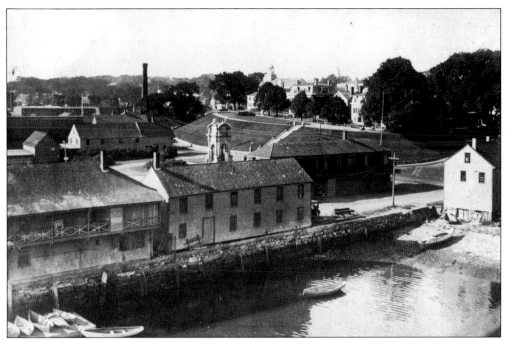

WATER STREET FROM THE COAL WHARF LOADING TOWER, C. 1890. The building on the left with the porches was the Plymouth Yacht Club. The Billings canopy over Plymouth Rock is at the center of the picture, and the building to the right of the rock is the Plymouth Bottling Works.

THE PLYMOUTH WATERFRONT FROM A DREDGER, C. 1885. The picture extends from the Plymouth Foundry at the mouth of Town Brook on the left to the portico over Plymouth Rock on the right.

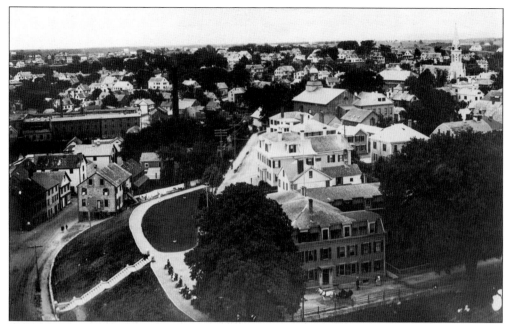

**WATER STREET, COLE'S HILL, AND SOUTH FROM THE CHIMNEY OF THE STREET RAILWAY POWER STATION, 1900.** This photograph was taken by John M. Lee. Note that Cole's Hill has been grassed over for only about one third of its length. The Plymouth Rock Hotel is in the foreground.

**A VIEW LOOKING NORTHWEST FROM THE CHIMNEY OF THE STREET RAILWAY POWER STATION, 1900.** This photograph of Winslow, Brewster, and Water Streets was taken by John M. Lee. Note the Plymouth Rock Shoe Company building, which had just become Mabbett's Woolen Mill, on the right.

86

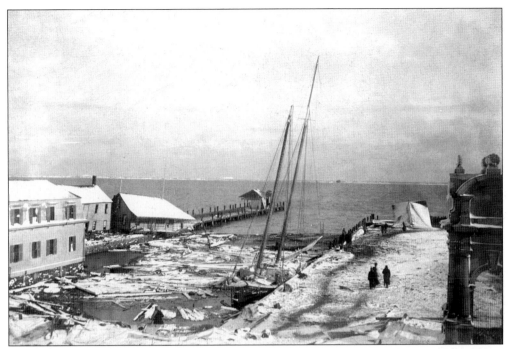

THE PLYMOUTH WATERFRONT, SHOWING EFFECTS OF THE PORTLAND GALE OF NOVEMBER 28, 1898. Note the destruction of the Plymouth Yacht Club, the third building from the left, on Long Wharf.

THE BREWSTER FAMILY BEHIND 1 CARVER STREET, C. 1900. From left to right are William, Ellis, Sarah, Lois, and Aunt Anne.

**MIDDLE STREET ON THE SOUTH SIDE, C. 1960.** This picture was taken just preceding the razing of the DeStefano building (right), the Middle Street Garage, and the house next to the Memorial Press Building (flat-topped structure to the left) for the present parking lot.

**THE SITE OF THE NATHANIEL MORTON (DR. BROWN'S) HOUSE, ON SHIRLEY SQUARE, 1940.** The First National supermarket building, now Fleet Bank, replaced the house. In this view looking north, note the houses (now removed) on Jackson Place to the right.

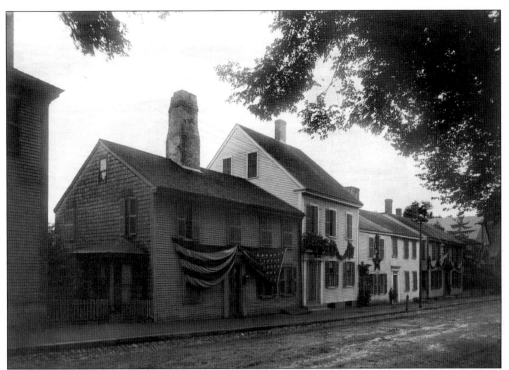

**North Street on the North Side, 1889.** The decorations were for the celebration marking the completion of the Forefather's Monument. The first and sixth houses from the left have been torn down, but the others survive. The third house is now the Yankee Book and Art Gallery, located at 10 North Street.

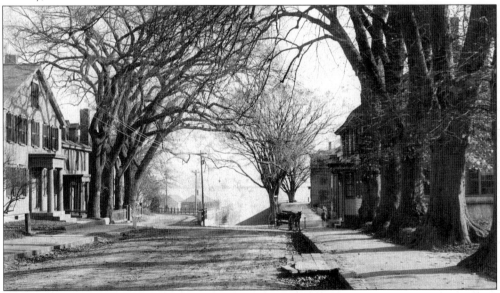

**North Street in a View Looking East, 1893.** The elms to the left are in front of the Jackson House, and the lindens to the right fenced a vacant lot where the Morton house, which burned in 1833, became the site of the Russell Library in 1904. The Spooner House is just to the left of the lindens. The Plymouth Bottling Works on Long Wharf is at the foot of the street.

**DR. NELLIE PIERCE (HELEN F. PIERCE) ON HER 90TH BIRTHDAY, APRIL 1, 1957.** Dr. Nellie Pierce was Plymouth's beloved first woman physician.

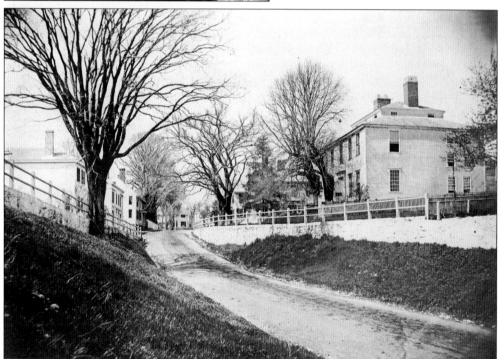

**NORTH STREET IN A VIEW LOOKING WEST, C. 1880.** The Winslow house at the right of the picture was bought by Charles Willoughby in 1898, moved back from the street, and renovated by Joseph Chandler in Colonial Revival style, adding wings, porches, and balustrades. It was bought by the General Society of Mayflower Descendants in 1941.

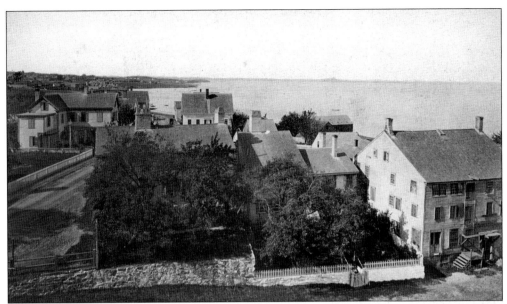

LOWER NORTH STREET AND SAMARIA OR OCEAN PLACE, IN A VIEW LOOKING NORTH, c. 1885. Of the three buildings in the foreground, only Dr. Reed's joined house in the center survives. The warehouse on the right is on the site of the Pilgrim Mothers' monument and fountain.

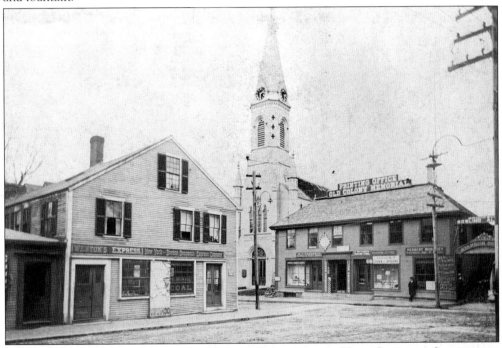

THE INTERSECTION OF MAIN AND LEYDEN STREETS IN A VIEW LOOKING SOUTHEAST, c. 1890. From left to right are Weston's Express Building, the Plymouth Baptist Church, Lyceum Hall, and the entrance archway to the Plymouth Armory. The Lyceum Hall (Old Colony Memorial) was torn down to make way for Main Street Extension in 1908, and the church was torn down a few years later for the new Plymouth post office.

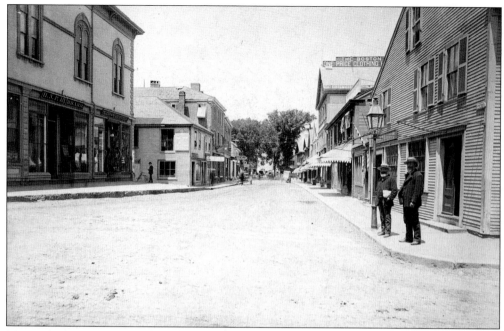

**MAIN STREET IN A VIEW LOOKING NORTH FROM LEYDEN STREET, C. 1885.** Main Street was widened in 1887 by moving or razing the buildings on the west side of the street, beginning with the second structure from the left.

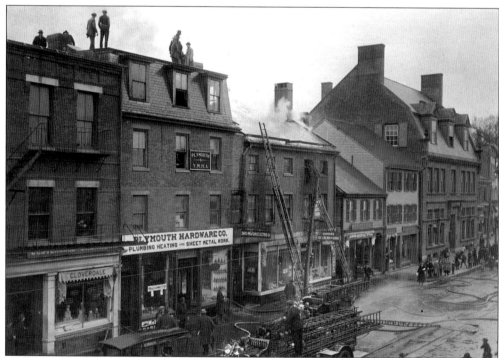

**A FIRE AT 22 MAIN STREET, C. 1920.** Waldo Currier began his ice-cream business here in 1900, later moving to 68 Main Street. The site was later occupied by McLellan's Five and Ten, the Mug and Muffin Restaurant, and now by Sean O'Toole's Pub.

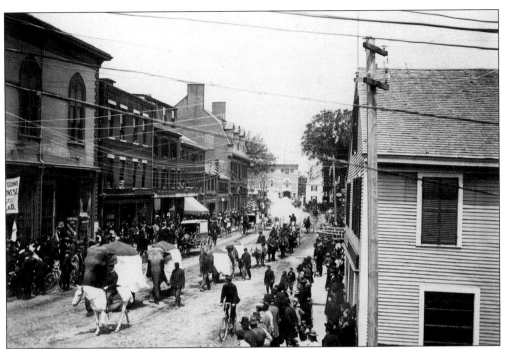

**THE JOHN ROBINSON & FRANKLIN BROTHERS CIRCUS PARADE.** This parade was held on Main Street in 1900.

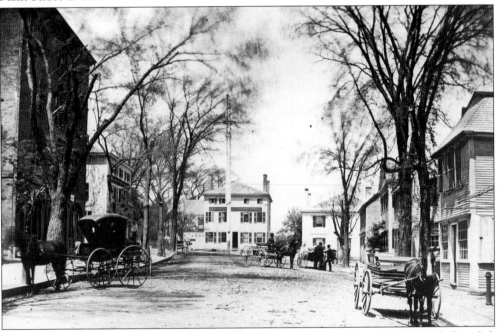

**SHIRLEY SQUARE FROM MAIN STREET IN A VIEW LOOKING NORTH, C. 1870.** Visible from left to right are Davis Hall, Central House, Avery & Doten Printing, the Nathaniel Morton house, the Warren House, the Goddard House, and the Hayward House. Today, these are Main Street Antiques, the Puritan Clothing building, the Howland Block (1892), Fleet Bank building, the Sandwich and Deli, Stephens the Florists, and Sam Diego's (the old firehouse).

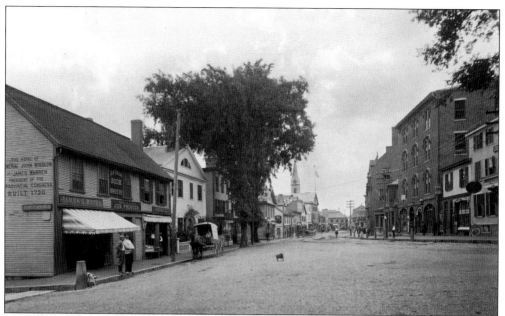

**MAIN STREET, C. 1900.** This view looks south from Shirley Square.

**THE WINSLOW-WARREN HOUSE, ON THE CORNER OF NORTH AND MAIN STREETS, C. 1925.**
The house was built in 1730 by Gen. John Warren, famous for evicting the Acadians as related
in Longfellow's *Evangeline*, and it was later occupied by James and Mercy Otis Warren. It was
refitted with small windows and stained an antique brown in 1975 for the bicentennial.

THE HAYWOOD HOUSE, AT 51 MAIN STREET, C. 1875. Built in 1685 (north wing) by Nathaniel Clark, the old house was where the Old Colony Club reorganized in 1875. The building was sold to the town in 1877 to build the Central Fire Station.

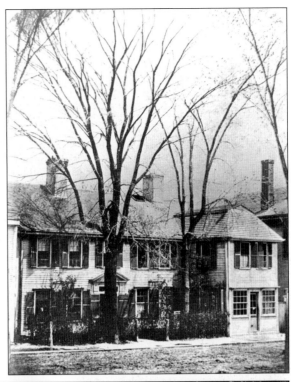

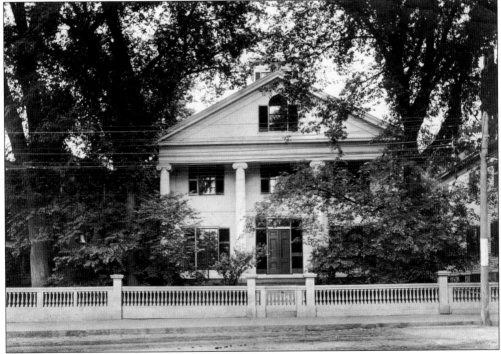

THE LOTHROP OR STODDARD HOUSE, AT 58 MAIN STREET, C. 1890. This house was built by Nathaniel Russell in the 1840s. It was removed to build the Plymouth National Bank building in 1929, which was absorbed in Puritan Clothing's expansion and is now the Plymouth Market Place.

95

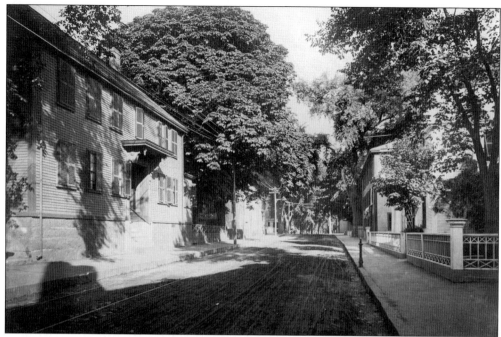

**COURT STREET IN A VIEW LOOKING NORTH FROM SHIRLEY SQUARE, C. 1895.** From left to right are the Chandler House, the Thomas House, the old bank building, and Dr. Brewster's House.

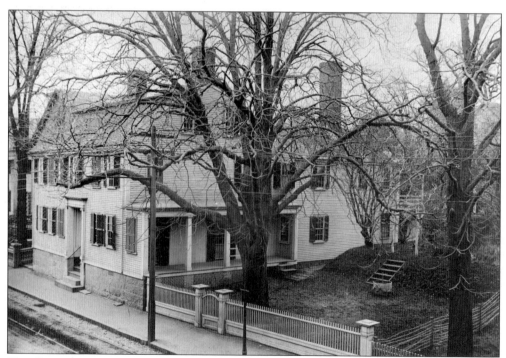

**THE CHANDLER HOUSE, AT 4 COURT STREET, C. 1900.** The house was moved to the rear of the lot to face School Street c. 1903, making room for the Moore Brothers (Buttner's) Dry Goods Store. It burned down in 1983.

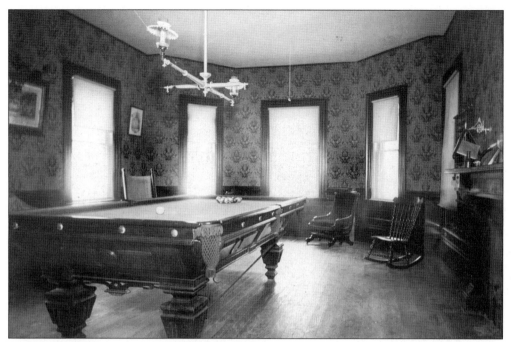

THE BILLIARD ROOM IN THE CHANDLER HOUSE, C. 1895. The Chandler House was located at 4 Court Street.

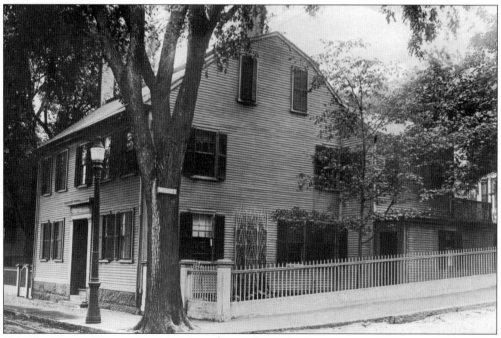

THE BARTLETT HOUSE, ON THE CORNER OF COURT AND SOUTH RUSSELL STREETS, IN A VIEW LOOKING SOUTHWEST, C. 1900. Built by Joshua Sturtevant in 1739 and occupied by Capt. Charles Dyer during the Revolution, the house was bought by William Bartlett, the father of John Bartlett of *Familiar Quotations* fame. The house was torn down in 1940, and the Jubilee Cafe occupies the site today.

**THE JOHN BARNES HOUSE, AT 4 SOUTH RUSSELL STREET, C. 1890.** The house was later replaced with an office building.

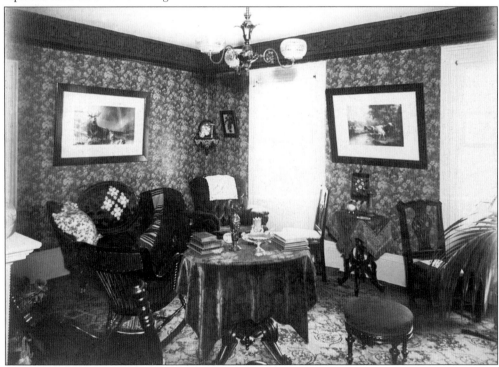

**THE PARLOR OF THE JOHN BARNES HOUSE.** The John Barnes House was located on the southwest corner of School and South Russell Streets c. 1890.

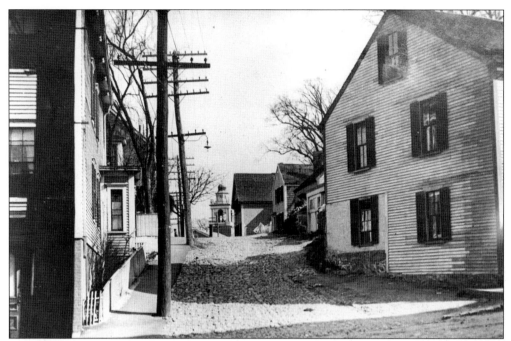

School Street in a View Looking South from the corner of South Russell Street, in front of the Plymouth County Court House, c. 1890. The buildings to the right were removed before 1930 to restore the northeast part of Burial Hill after the Pilgrim tercentenary.

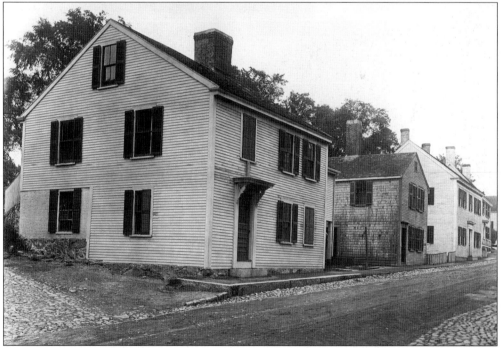

South Russell Street in a View Looking Southwest from the Corner of School Street, c. 1890. These houses, which backed on to Burial Hill, were removed during the first half of the 20th century. The last house to go, on the extreme right, survived to the early 1950s.

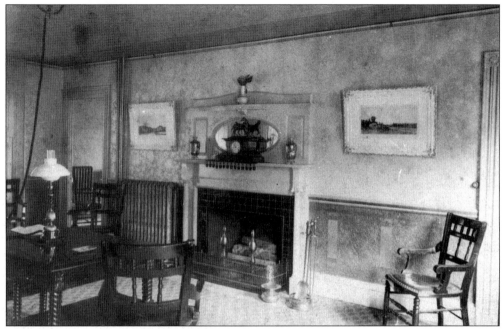

**THE INTERIOR OF THE OLD COLONY CLUB HOUSE, AT 25 COURT STREET, 1893.** The club bought its permanent quarters in 1893. This picture shows the newly decorated main room. Note the gas extension light with tube on the left.

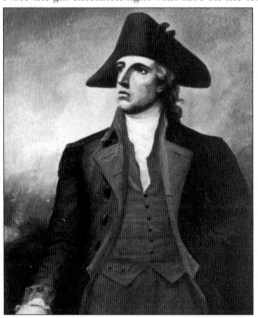

**LEFT: ALEXANDER SCAMMEL (1747–1781). RIGHT: WILLIAM T. DAVIS (1822–1907).** Alexander Scammel was a Plymouth schoolteacher who became a Revolutionary War general and was killed at Yorktown. He taught school in the old grammar school on School Street. William T. Davis was a lawyer, bank president, and town historian, compiling his exhaustive *Ancient Landmarks of Plymouth* (1883) and his entertaining *Memories of an Octogenarian* (1907). Both Scammel and Davis were members of the Old Colony Club.

**ARTHUR LORD (1850–1925).**
Plymouth historian Arthur Lord was president of the Old Colony Club. He was also president of the Massachusetts Bar Association, the Massachusetts Historical Society, and the Pilgrim Society (1895–1925). Lord was instrumental in expanding the fame of the Pilgrims and their town. He was the author of *Plymouth and the Pilgrims*, published in Boston in 1920.

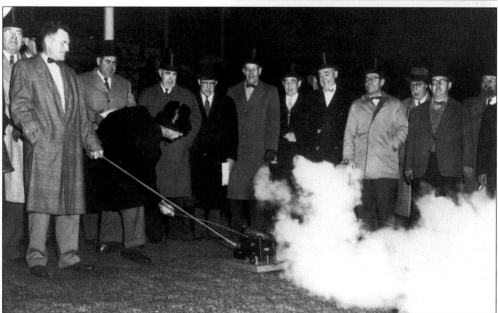

**THE OLD COLONY CLUB REINTRODUCES THE FOREFATHERS' DAY DAWN MARCH, DECEMBER 22, 1956.** Under the guidance of Lauris "Brad" Bradbury, the Old Colony Club fires a signal cannon at dawn in front of the Plymouth County Court House, recalling the annual event imitated by the club in 1769.

*Left:* Dr. James Thacher (1754–1844). *Right:* Rose T. Briggs (1893–1981). Dr. James Thacher wrote the town's first comprehensive history in 1832. He was the Pilgrim Society's first "cabinet keeper" (curator). Rose T. Briggs was Plymouth's most eminent authority on the Pilgrims for many years, becoming the Pilgrim Society's first director in 1957.

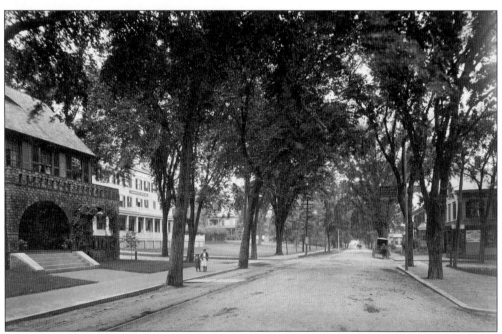

Court Street at the Corner of Samoset Street in a View Looking North, c. 1895. The Samoset House Hotel is second from the left, now the site of Papa Gino's; the "Elms" is next beyond Samoset House; and William Burns' Grocery, now the Verc Mobile station, on the corner of North Park Avenue, is on the right.

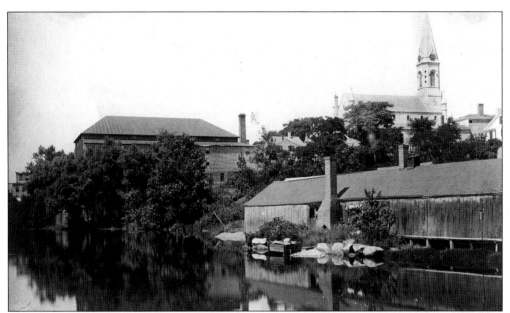

THE TOWN POND IN A VIEW LOOKING NORTHWEST, C. 1890. The large structure on the left, now the site of the Emond Building, is the Standish Guards Armory (or Casino), which also housed a bowling alley, roller rink, and the Godfrey Seamless Pocket Company. The Baptist church steeple, the backs of Leyden Street houses, and the E. and J.C. Barnes sawmill are also visible.

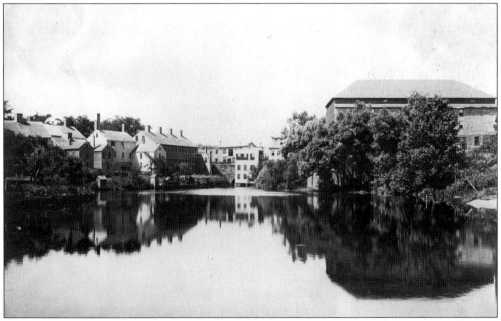

THE TOWN POND IN A VIEW LOOKING WEST FROM THE WATER STREET BRIDGE TO THE MARKET STREET BRIDGE, C. 1890. The tidal pond, formed by damming Town Brook at Water Street, was becoming increasingly noisome from pollution by 1900. (Note the outhouses on the south bank of the brook.) The Main Street Extension bridge divided the pond in 1908, and the pond was filled in to create Brewster Gardens in 1924.

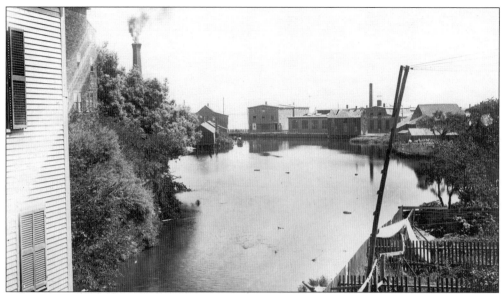

THE TOWN POND IN A VIEW LOOKING EAST FROM MARKET STREET BRIDGE, C. 1895. From left to right are Fuller's Drug Store (46 Market Street), the Standish Guards Armory, the chimney of the Plymouth Electric Light and Power Company, the Plymouth Foundry, and the yards behind the Gale Block on Sandwich Street.

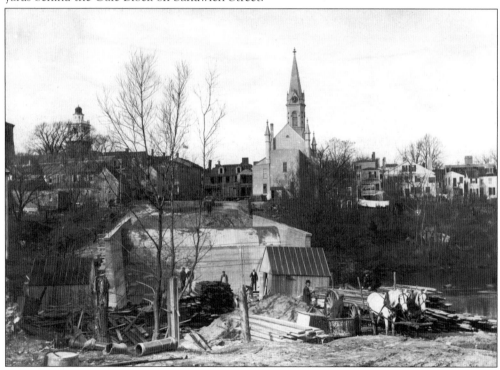

BUILDING THE MAIN STREET EXTENSION BRIDGE IN A VIEW LOOKING NORTH FROM SANDWICH STREET, 1908. Leyden Hall and the Standish Guards Armory have been demolished, but the Baptist church, replaced by the post office in 1913, remains on the corner of Leyden Street in the center of the picture.

SANDWICH STREET (LEFT), MARKET STREET (FOREGROUND), AND PLEASANT STREET (RIGHT), C. 1870. This view looks south from the steeple of the First Parish Church. Note that the Town Pond extends to the Market Street Bridge before the Main Street Extension linked Main Street and Sandwich Street.

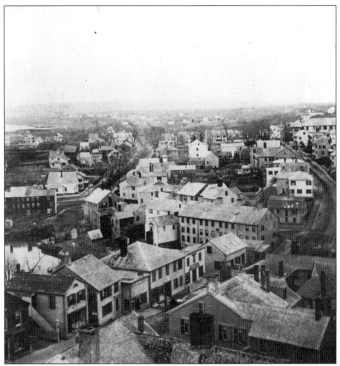

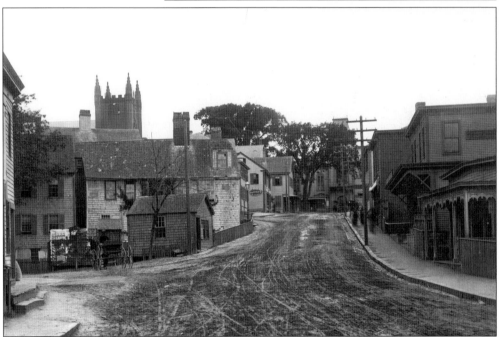

MARKET STREET IN A VIEW LOOKING NORTH TOWARD THE ODD FELLOWS BUILDING AND THE PLYMOUTH TOWN SQUARE, 1892. I. Morton's gristmill is on the extreme left, on the corner of Mill and Market Streets. Mill Street used to connect to Summer Street, which entered Market Street beyond the houses in the center of the picture. The 1831 Gothic First Parish Church tower is on the right.

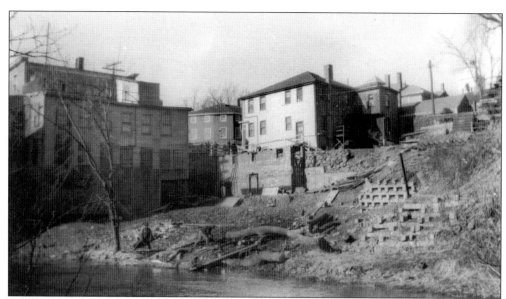

MARKET STREET DURING THE CONSTRUCTION OF THE MAIN STREET EXTENSION PARKING LOT, C. 1950. The brick building in the center of the picture was on the corner of Market and Summer Streets.

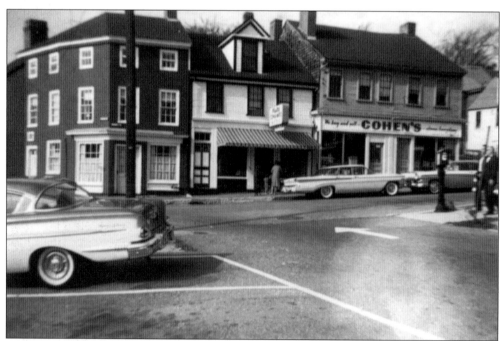

MARKET STREET ON THE WEST SIDE, BETWEEN SUMMER AND HIGH STREETS, 1962. These buildings were removed by the Plymouth Redevelopment Authority to build the new Holiday Inn parking lot. The site is part of the John Carver Inn property today.

106

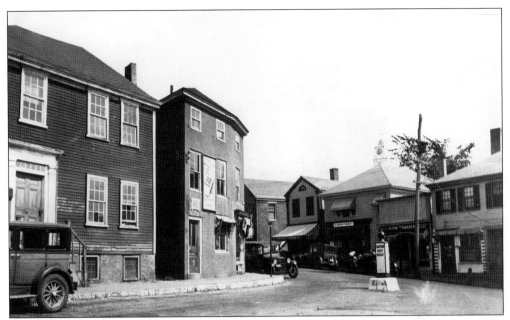

THE CORNER OF SUMMER AND MARKET STREETS IN A VIEW LOOKING NORTHEAST, C. 1920.
The Cooper House and the brick house on the corner, the site of the first prison of 1642, are where the entrance of the John Carver Inn parking lot is today. The other buildings were removed for the construction of the present Dunkin' Donuts and Tedeschi's Grocery.

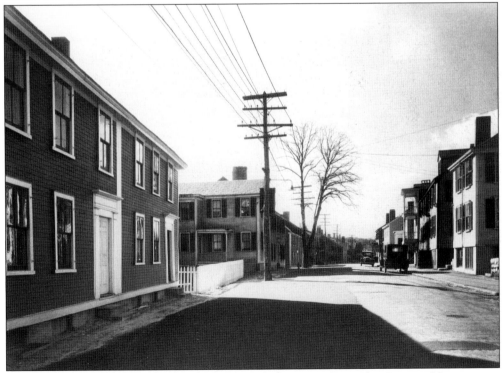

LOWER SUMMER STREET IN A VIEW LOOKING WEST, C. 1920. The Sparrow House is just beyond the elm tree.

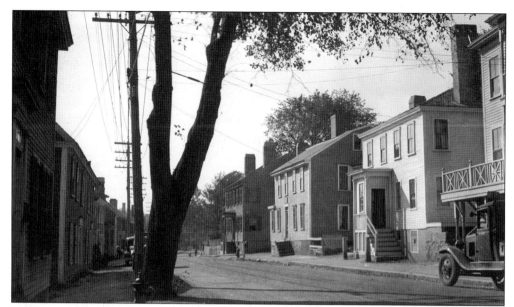

**LOWER SUMMER STREET IN A VIEW LOOKING NORTHWEST, C. 1920.** The third house from the right is the Leach-Bonum house (*c.* 1670), which was demolished by the Plymouth Development Authority in the mid-1960s. Just beyond it is the Bishop House, which was moved to about where the picture was taken from on the south side of the street.

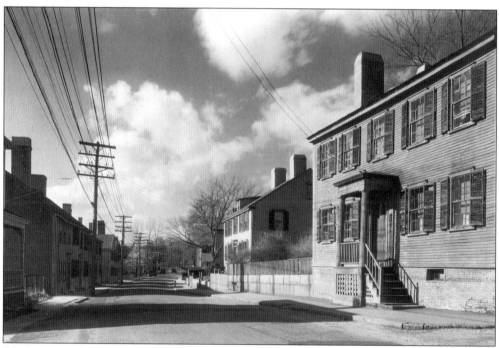

**SUMMER STREET FROM THE CORNER OF SPRING LANE, C. 1925.** Many of the houses in this picture were demolished during the redevelopment project in the 1960s. The Finney House (third from the right) was moved up to Church Street to become part of the First Church Parish House, and the Bishop House (far right) was moved across the street and restored.

**KATHERINE ALDEN (1893–1976).** Katherine Alden operated the Plymouth Pottery in the restored Sparrow House from 1932, giving classes to local students in redware and selling their work in the attached shop.

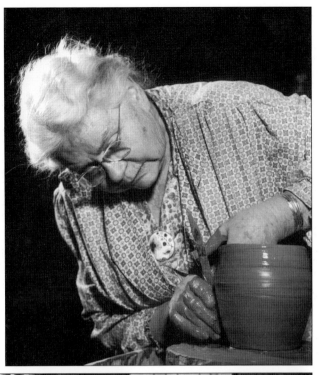

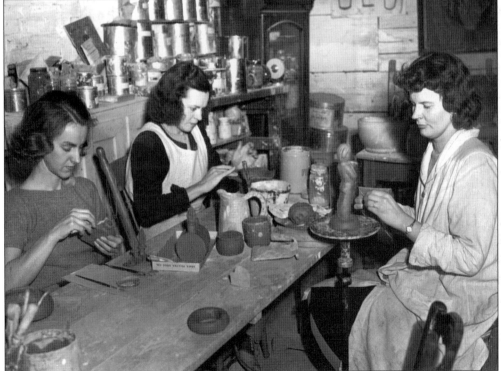

**THE PLYMOUTH POTTERY, AT 42 SUMMER STREET, C. 1940.** From left to right are Katherine Davis, Leslie Swift, and Ruth E. Pope.

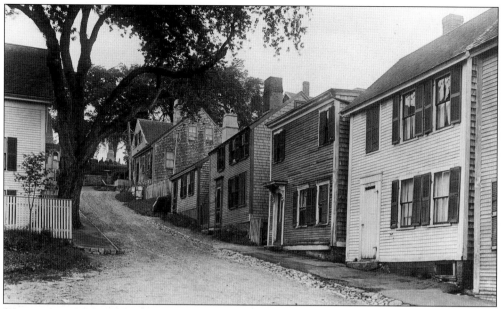

Spring Street on the East Side in a View Looking North toward Burial Hill, c. 1900. All of these houses were demolished by the Plymouth Redevelopment Authority in the early 1960s. The street is now a paved footpath just west of the John Carver Inn on Summer Street.

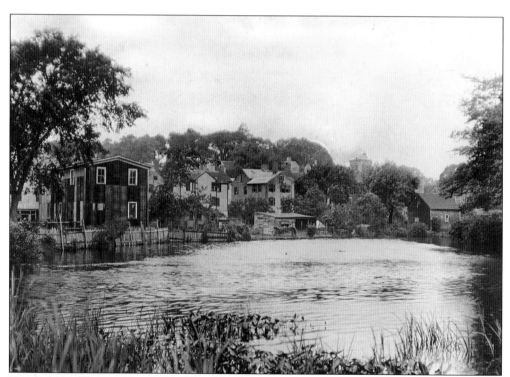

Poorhouse Pond in a View Looking Northeast toward Summer Street Backs, 1926. The Spring Lane milldam that creates this pond is now the location of the Jenney gristmill, which began in 1970.

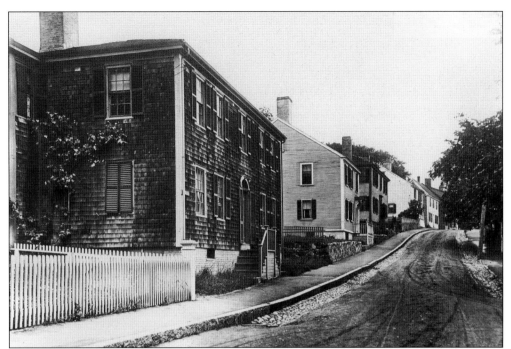

**High Street on the Corner of Russell Street in a View Looking East, c. 1900.** The Ryder Home (left) is the only surviving feature in this picture; even High Street itself was obliterated during the Plymouth Redevelopment Authority's destruction of the old, low-income neighborhood.

**Church Street in a View Looking West, 1940.** The First Parish Church is on the right, and the entrance to Cooper's Alley just beyond the first house is on the left, now west of the Church of the Pilgrimage's parish house.

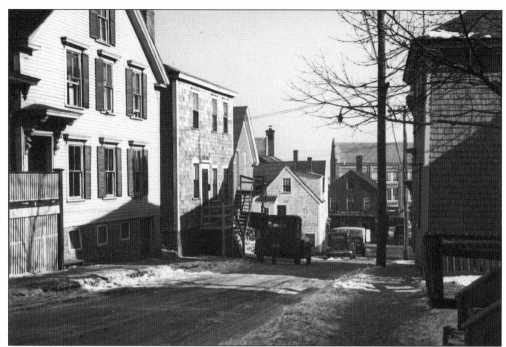

HIGH STREET IN A VIEW LOOKING EAST TOWARD DUNHAM'S BAKERY AND THE EMOND BUILDING, 1940. The High Street entrance to Cooper's Alley is between the first two houses on the left.

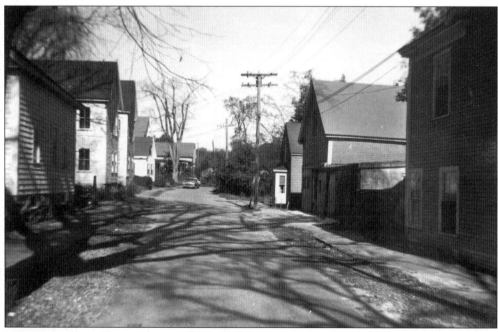

EDES STREET IN A VIEW LOOKING NORTH FROM SUMMER STREET, 1962. All but one of these houses (fifth from the right) were demolished by the Plymouth Redevelopment Authority a few years later.

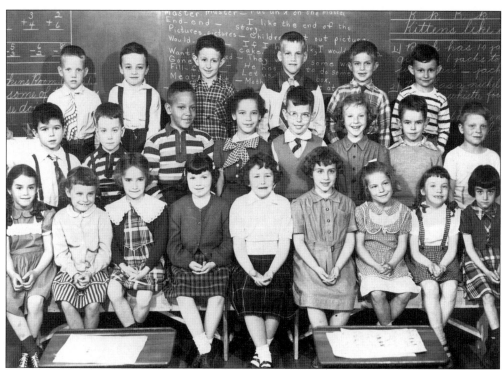

**First- and Second-Grade Classes of the Oak Street School, 1951.** Plymouth's oldest school, which opened in 1902, has not changed outwardly for decades and is still in use today.

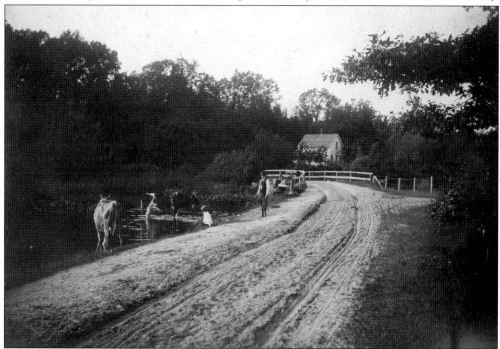

**Deep Water Bridge, on Billington Street, c. 1890.** Looking northeast, this rural scene was taken where Billington Street crosses Town Brook just before going under Route 3.

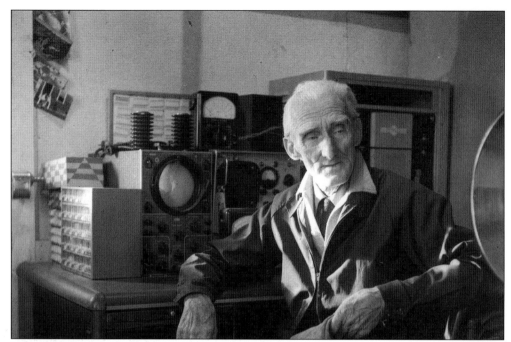

HAROLD MANSFIELD AMID HIS RADIO EQUIPMENT, C. 1970. Mansfield was Plymouth's pioneer in electronics and radio communication and had a shop at 5 Main Street in the 1920s. This photograph was taken by Anthony I. Baker.

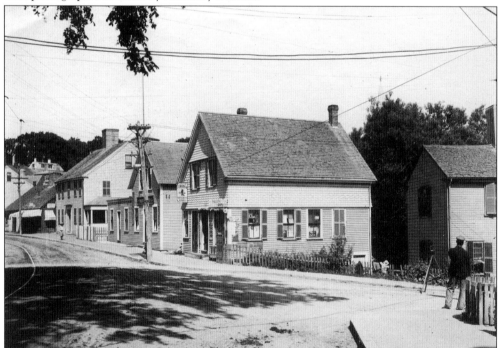

THE CORNER OF SANDWICH AND WATER STREETS IN A VIEW LOOKING NORTH, C. 1905. The surveyor is standing where the entrance of the Reliable Cleaners parking lot is today. Main Street Extension now goes directly through the house lots in the center of the picture.

114

**THE ATWOOD-ROBBINS LUMBER COMPANY, ON UNION STREET, C. 1930.** The lumber company had consolidated its operations below the Holmes Reservation on Court Street, and this building was soon after renovated by the Plymouth Yacht Club, which still occupies it today.

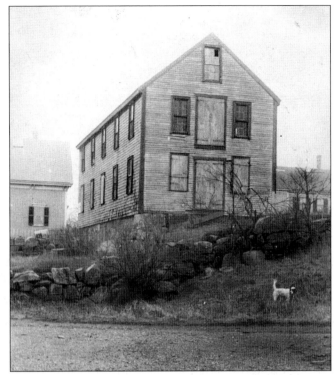

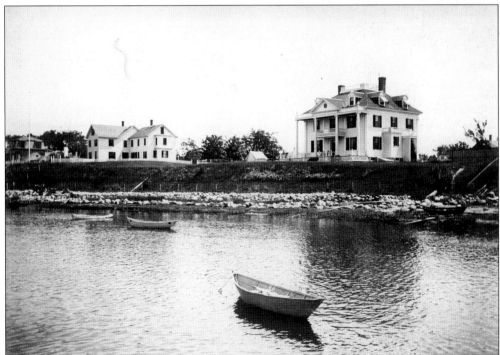

**HOUSES ON THE PLYMOUTH SHORE ON UNION STREET, C. 1900.** The Stevens house can be seen on the left, and the Burgess house is in the center. The Kyle House (right), at 40 Union Street, burned in 1979, and the site is now a parking lot for the Plymouth Yacht Club.

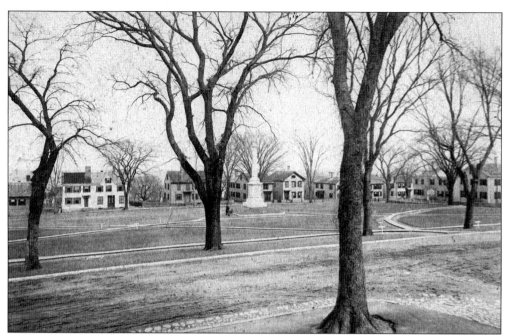

THE TRAINING GREEN IN A VIEW LOOKING EAST FROM PLEASANT STREET, C. 1880. The fourth house from the left was removed to provide access to the Nathaniel Morton School. The Civil War Memorial was erected in 1869.

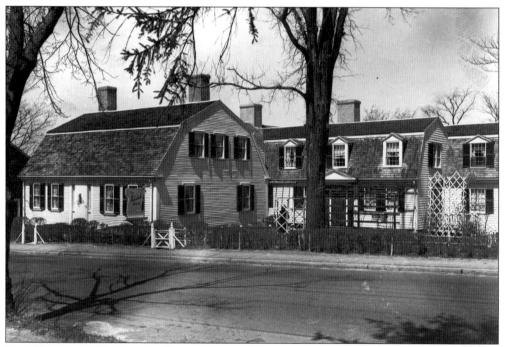

THE HOBSHOLE HOUSE, ON SANDWICH STREET, C. 1960. This was the home of Ichabod Morton, a pioneer in educational reform and the temperance movement. His daughter Abbie became a popular author of children's books and feminist essays. The old house was an inn and restaurant in the 1940s and 1950s and became a condominium in the 1980s.

LEFT: NATHANIEL MORTON (1831–1902). RIGHT: AUSTIN MORTON, ABBY MORTON DIAZ, MARIAN MORTON, AND ANDREW RUSSELL, C. 1890. Nathaniel Morton was a leader in the new conservation movement. He organized the creation of Forest Park (now Morton's Park) on Billington Sea. His sister Abby Morton Diaz met her future husband, Manuel Diaz, at the famous Brook Farm commune. This scene may have been from a dramatization of *The William Henry Letters*, her bestselling children's book.

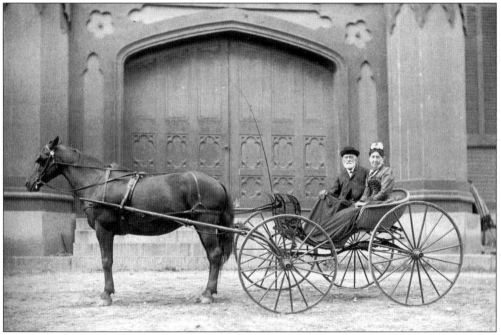

MR. AND MRS. GEORGE E. MORTON IN FRONT OF THE FIRST PARISH CHURCH, 1880. Morton was the brother of Nathaniel Morton and Abby Morton Diaz.

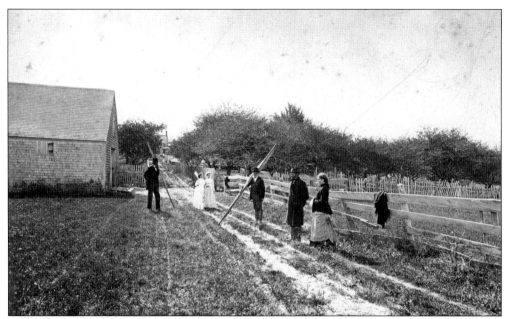

HOWES LANE IN A VIEW LOOKING WEST, C. 1890. This view shows Howes Lane before it opened as a public way in 1891–1892. From left to right are Sam B. Holmes and his cottage, two unidentified girls, Amasa Sears, Walter H. Sears, and Genie C. Sears.

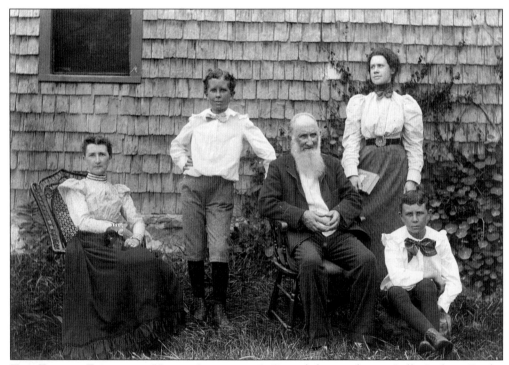

THE FOWLER FAMILY ON HOWES LANE, 1895. From left to right are Pella Perkins Fowler (widow of Charles I. Fowler), Percival, William A., Elizabeth, and Charles Fowler.

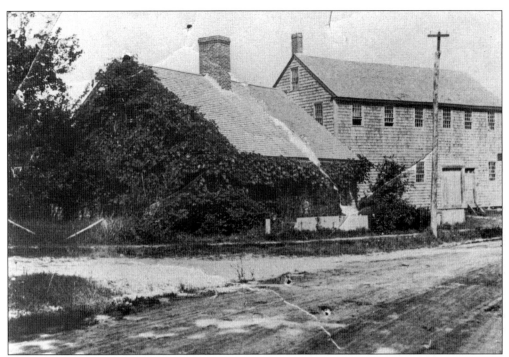

GRAPEVINE COTTAGE, AT 251 SANDWICH STREET ON THE CORNER OF OBERY STREET, C. 1900. Note the sail loft on the right on the site of the first Wellingsley school.

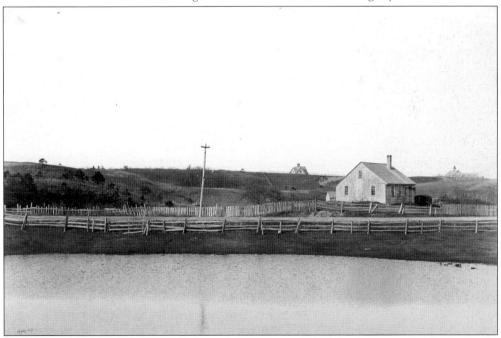

JIM CHURCHILL'S HOUSE, ON SANDWICH STREET, C. 1900. This was one of two houses between Jordan Hospital and Cliff Street. Note the bare landscape—there were few trees between Jabez Corner and Eel River. The two barns in the distance belonged to the Litchfield and Bates families.

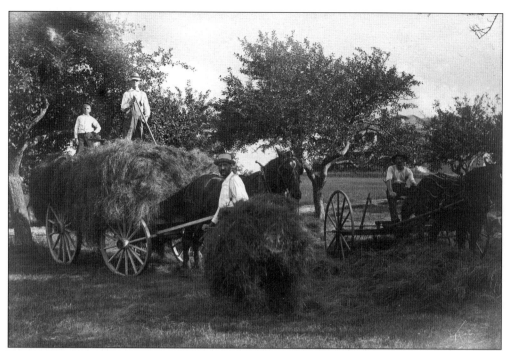

**JAMES "SWEARING JIM" FINNEY HAYING NEAR CLIFF STREET, C. 1900.** This photograph was taken by Ed Hoxie.

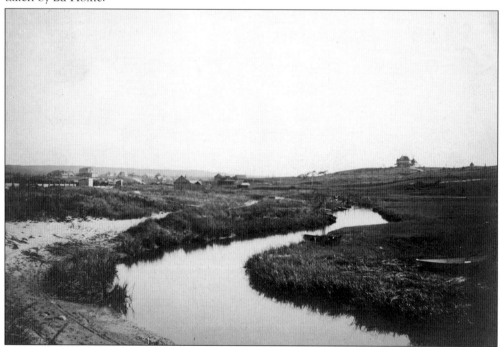

**EEL RIVER BELOW MANTER'S POINT IN A VIEW LOOKING SOUTH, C. 1890.** The large house on the hill to the right is the B.R. Curtis House, which was bought by the Hornblower family c. 1898. It is located where the Plimoth Plantation Fort/Meetinghouse is now. Note the lack of trees in this view, which is now heavily wooded.

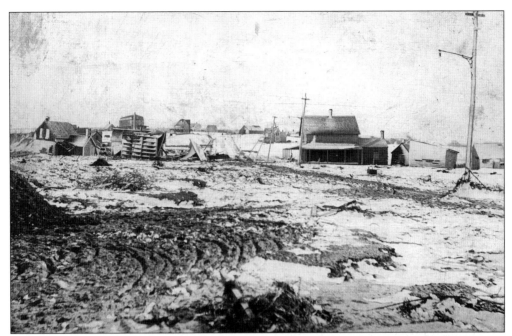

**THE HEAD OF PLYMOUTH BEACH FROM THE WARREN AVENUE ENTRANCE TO THE BEACH, 1898.** Looking south, this view shows the effects of the Portland Gale of November 28, 1898. Note the Hotel Pilgrim on the hill crest on the left of the picture.

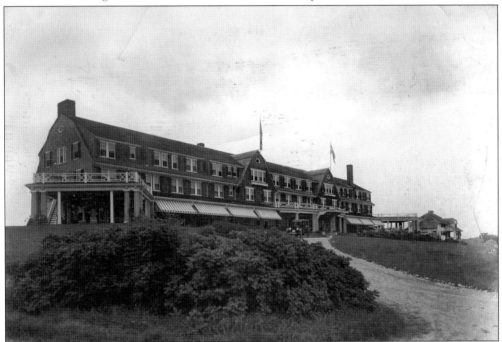

**THE MAYFLOWER HOTEL, ON POINT ROAD IN MANOMET, C. 1920.** Built in 1916, the Mayflower Hotel had 170 rooms in the main and extension buildings and numerous other facilities in a Shingle-style building that captured the image of a New England coastal retreat. It was demolished following two fires in 1975.

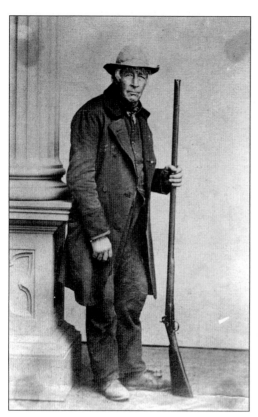

**BRANCH PIERCE (1790–1865), PLYMOUTH'S MOST FAMOUS GUIDE.** "For miles around, there is not a hill or rock, noted tree but is known to him; not a pond nor brook or river. The network of roads so embarrassing to other men at noon, are no puzzle to him at midnight." Men such as Daniel Webster came to Plymouth for hunting, and Pierce was their most valuable resource. He himself killed 267 deer with his famous gun, "Old Appletree."

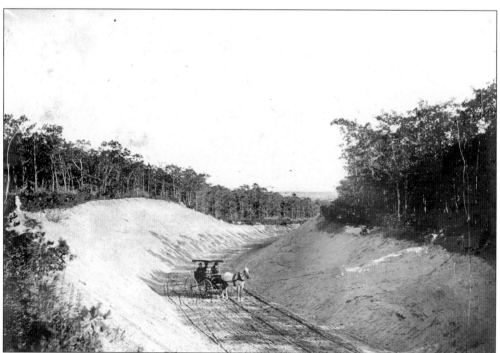

**STATE ROAD IN MANOMET, C. 1900.** This view looks south from the crest of the Pine Hills.

**DR. ROBERT M. BARTLETT, C. 1965.**
Reverend Bartlett was an avid Plymouth historian who wrote and lectured on the Pilgrims and Plymouth history and attempted to improve upon the popular perception of the colonists' religious and social lives.

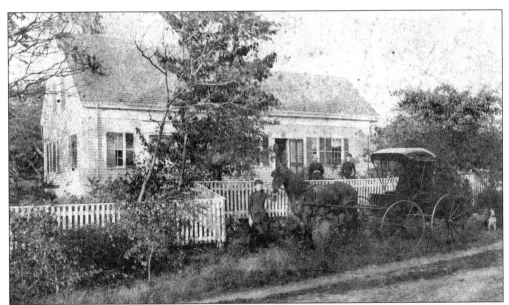

**THE DOUGLAS HOUSE, ON HALFWAY POND, C. 1900.** The old farmhouse, built in 1813, was bought by Mrs. George G. Barker, a wealthy summer resident who named it Roadside and let friends, such as George R. Briggs, use it as a cottage. It was torn down in 1940.

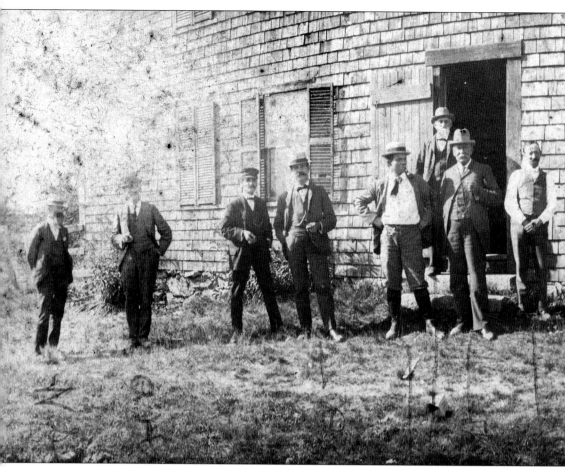

**The Jabez Corner Chowder Club, at the Burgess Farm on Boot Pond, c. 1895.**
From left to right are Walter Sears, Albert Harlow, Frank Carleton, Dr. E. Dwight Hill, Dr. John Churchill, Ichabod Morton, "Lon" Warren, Herbert Howland, Isaac Jackson, Capt. "Lem" Burgess, Addison Fay, Tom Eldridge, Thomas E. Cornish, Capt. Lemuel Howland, William Morrissey, Bill Edes, and "Anse" Bartlett (holding broom as parade marshal's baton). Once

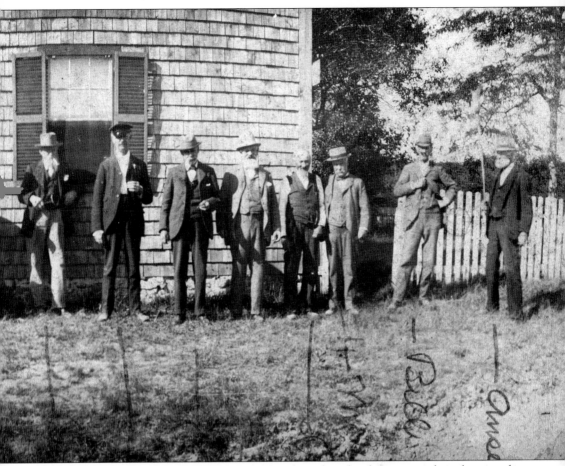

when the group assembled for "Marm" Burgess's clam chowder dinner served outdoors at the Burgess place on Boot Pond, a shower came up. One of the "Hobbs Hole boys" seized the steaming cauldron at his end of the long table and ran with it into the house, crying, "In the name of Cromwell, fear God, and keep your *chowder* dry!"

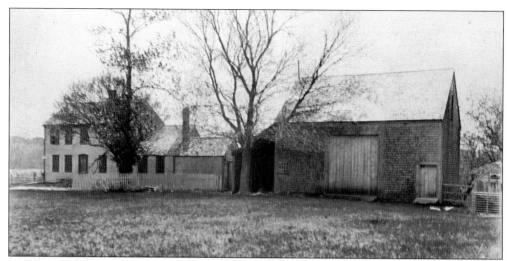

**THE BURGESS FARM, ON BOOT POND, C. 1890.** The Burgess family owned the farm between Boot Pond and Great South Pond from 1801 to 1959. It was a favorite spot for local artists, picnickers, campers, and the Jabez Corner Chowder Club. Sue and Mary Burgess hosted amateur theatricals in the barn. Carroll Daley bought the farm, or "Kamesit," in 1959.

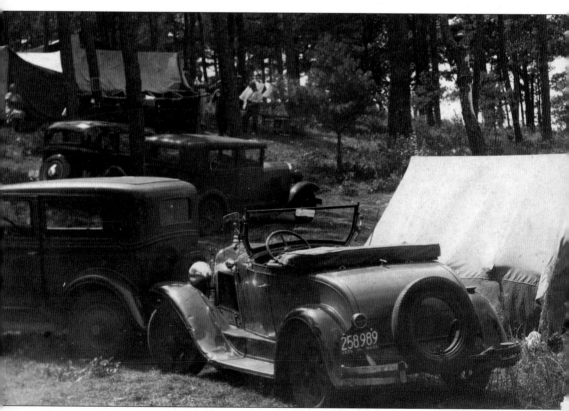

**CAMPING AT FRESH POND CAMPGROUND, 1934.** "About six miles from Plymouth on Route 3, southerly. A sign will indicate the road leading to the camp grounds. 18 acres. Bathing beach. Rates: 50c per lot per day; $3.50 per week; $6.00 for two weeks; $8.00 for three weeks; $10.00

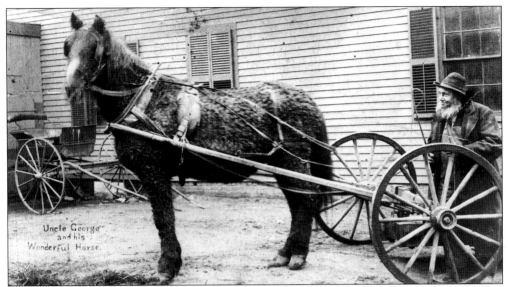

**UNCLE GEORGE AND HIS WONDERFUL WOOLY HORSE, 1892.** Bagnall, a teamster, found his horse's fame annoying, as it attracted amateur photographers. He sold it to a man for $250 to take around the country to exhibit.

for a month; $18.00 for two months; $25.00 for three months." This photograph was taken by manager Seth Wall.

**JIM BURR'S HOUSE, AT PARTING WAYS, C. 1900.** Parting Ways, on the Plymouth-Kingston line, was a neighborhood of properties that had been given to black Plymouth Revolutionary War veterans.

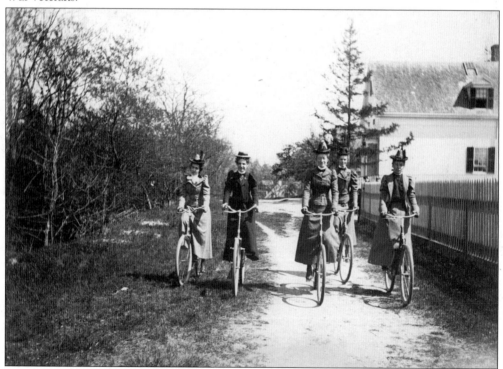

**BICYCLING IN PLYMOUTH, C. 1900.** From left to right are Lydia Bradford, Mary Mullen, Emma Hall, Mary Bennett, and Fannie Smith.